MALVERN COLLEGE

125
YEARS

Compiled by

GEORGE CHESTERTON

Published in 1990 by
The Malvern Publishing Co Ltd
Lloyds Bank Chambers,
18 High St, Upton-upon-Severn,
Worcs WR8 OHD

British Library Cataloguing in Publication Data
Chesterton, George
 Malvern College, 125 years.
 1. Hereford and Worcester. Malvern. Public boy's schools. Malvern College,
history
 T. Title
 373. 42447

ISBN 0 947993 60 6

Produced and Designed by Tapelk Ltd, Upton-upon-Severn, Worcs.
Printed in Great Britain by Tewkesbury Printing Co, Tewkesbury, Glos.

CONTENTS

Acknowledgements

Grateful acknowledgement is expressed to the following. Michael Ward for his generous permission to reprint some of his photographs prepared for Age Frater, and likewise to Reed Midland Newspapers Ltd and The Worcester Evening News to reproduce the most up to date pictures at the end of the book; to Bill Denny for the use of many of his drawings, to Norman Rosser the College Archivist, and to Tony Hoper for the use of his collection of post cards. Finally to Karen Hill of Tapelk Ltd for the design and layout and Chris Redman for the cover of this book.

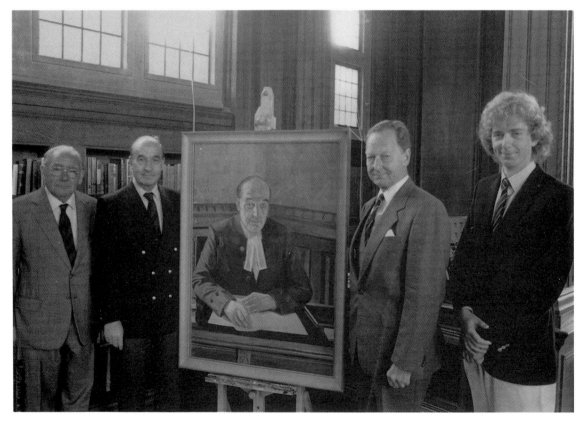

This portrait of the Rt. Hon. B.B. Weatherill, M.P., Speaker of the House of Commons and President of the Malverian Society, was painted by J.M. Ellis of the Art department. It was handed over to the College by D.J.N. Thompson, Chairman of the Society Committee and Chairman of the Old Malvernian Club, and received by Sir Stephen Brown, Chairman of the College Council.

From left to right: D.J.N. Thompson, The Rt. Hon. B.B. Weatherill, Sir Stephen Brown, J.M. Ellis. *(Reprinted by kind permission of The Malvern Gazette)*

Introduction

I am indeed grateful to the Old Malvernian Club, whose committee made funds available for the publication of this book, and also to Sir Stephen Brown, Chairman of the College Council who has given his blessing to the project. I felt strongly that a century and a quarter of the existence of the College should be recorded in some way. It has been a great pleasure to re-read Ralph Blumenau's history of the school and C.B. Lace's account of the Malvernian Society, both of which take the story of Malvern up to the centenary year of 1965. This book does not set out to be a history, but a scrap book of the first 125 years and might be considered as an appendix to these earlier records.

Independent schools provide an immensely important service, but in doing so they have to be financially viable. Many schools have generous endowments and backing from wealthy concerns, Malvern has never had such advantages. Four years after a financial crash which brought down half the banks of England "The Malvern Proprietary College" was founded, this was in the Imperial Hotel on 22nd August 1862. A remarkable act of faith. 500 shares of £40 each were put up for sale, this, and the later issues of debentures, much private investment and subscription funds, for one project after another, saw the school grow both in numbers and reputation, but always with a background of financial problems.

The Malvernian Society from its inception in 1903 set itself the task of relieving the Council of debt. All shares were bought in and a few months before the centenary the last outstanding debentures were acquired. This has been but one aspect of the Society's operations. It owns much land, and through subscriptions, bequests and investments has sufficient income to assist with a variety of projects at the Headmaster's request. The role of the Society is epitomised by using rent received for the Headmaster's house, which it owns, for the benefit of the school

The School's problems have not only been financial; after the first war there could have been no-one better suited than F.S. Preston to see Malvern through the social changes that followed and to weather the storm of the depression in the early thirties. No school suffered more than Malvern in the Second war; H.C.A. Gaunt not only guided Malvern safely through those dramatic years but in the period after raised the numbers to an economic level. A firm and skilful hand was then required to lift Malvern into the academic first division, D.D. Lindsay achieved this, and in doing so, what fun we all had!

The process of offering as good if not better than other schools is relentless. M.J.W. Rogers by introducing the first study bedrooms initiated a revolution which brought dramatic physical and social change to the school. The construction of an art school second to none and a sports hall as good as most, took the school into the eighties. Under the present Headmaster a personal tutorial system has come into operation and the presence of Ellerslie VIth form girls in the class room is no longer cause for comment. On the physical side refurbishment of the Houses has been completed; more money is to be raised, to build a Design and Technology Centre, and to lay an all weather sports surface as yet one project succeeds another.

BRICKS AND MORTAR

"Malvern Proprietary College"

A meeting was held on the 22nd August 1862 in Dr Gully's Dining Room at the Imperial Hotel, with the Bishop of Worcester in the Chair.

At a further meeting in September "The Malvern Proprietary College Company Limited was formed with 500 shares of £40 each.

The Hon. Frederick Lygon M.P. (Sixth Earth Beauchamp in 1866) was elected Chairman. Dr Leopold Stummes was elected Honorary Secretary.

The new company advertised for an architect and for a headmaster. Forty designs were submitted, and that of Charles Hansom, brother of the inventor of the Hansom cab, was chosen. He had already built Clifton College to a similar design.

The two drawings show that Hansom envisaged a chapel linked to the main building by a covered way.

In March 1863 The Rev. Arthur Faber, Fellow and Tutor of New College Oxford was selected as the first Headmaster.

Warburtons, of Manchester were contracted for the construction work. The main building was to be faced with Cradley stone at an estimated cost of £16,225.

The future Lord Beauchamp was responsible for building the Headmaster's House, later extended to become School House. The Malvern College Building Company was created with the express task of constructing boarding houses. Charles Hansom and Walburtons were retained to execute the work on No 1 and 2.

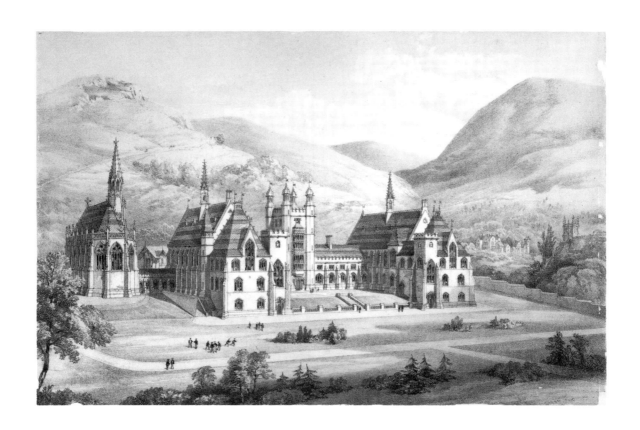

Hansom's design for the college showing the linking of the Chapel to the college building by a covered way.

MALVERN PROPRIETARY COLLEGE (LIMITED.)

FIRST CALL OR SECOND INSTALMENT—SIXTEEN POUNDS PER SHARE,
PAYABLE 1st JULY, 1863.

MALVERN, 28TH MAY, 1863.

Arrangements having been made for the Purchase of the Land on which the College is to be erected, the Council have thought it expedient to make a call of £16 per Share, making with the Deposit already paid, £20 per Share. The Council have accordingly passed a Ressoluton calling for £16 per Share, payable on the 1st July next, and I am instructed to request that you will pay the sum due on the Shares registered in your name at MESSRS. BERWICK, LECHMERE, AND Co's BANK, or the WORCESTER CITY AND COUNTY BANK, at WORCESTER or MALVERN, *depositing this Circular at the time of payment.*

The Council are happy to inform the Proprietors that the REV. A. H. FABER, M.A., Fellow and Tutor of New College, Oxford (selected by the Lord Bishop of Worcester), has been unanimously appointed Head Master, and that preparations are being made for laying the first stone in the month of July.

I am,

Your obedient Servant,

HENRY ALDRICH,

SECRETARY.

Regr. No. 5

_____ Shares, Nos. 397 & 398 £32

Amount of Call £16

Name Rev. H. F. Martin

Address Newark n Trent.

MALVERN PROPRIETARY COLLEGE (LIMITED.)

Regr. No. 5 — Name Rev. H. F. Martin Worcester, 3 Dec 1863.

Received the sum of Thirty Two Pounds,

for First Call or Second Instalment on Two Shares, Nos. 397 & 398

A call for shareholders and notice of the appointment of the first Headmaster.

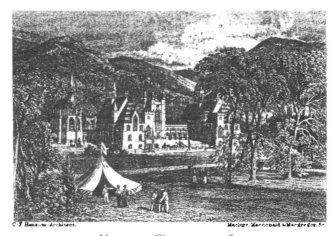

Malvern Proprietary College.

Malvern, Nov: 24 1863.

My dear Sir

Many thanks for your note of
23rd Inst: & Prospectus of Cheltenham Coll:
I should be glad to learn what its Masters
Salaries are — Yours Sincerely

Henry Aldrich. —
Secretary

C. F. Cooke Esqr
Cheltenham.

Cheltenham College had been opened in 1841, here the Secretary of the Malvern Proprietary College Company seeks the advice of his opposite number.

MALVERN PROPRIETARY COLLEGE COMPANY (LIMITED).

My Dear Sir

MALVERN, DECEMBER 7TH, 1863.

I am requested to call your attention to the following arrangement that has been made between this Company and the Malvern College Building Company (Limited) :—

In consequence of the imperative necessity of having Masters' Houses erected and ready for the reception of Pupils at the opening of the College in the Summer of next year, and the College Company not being able to devote funds to this purpose, an independent Company, called the Malvern College Building Company (Limited), and composed of Members of the Council and Proprietors of this Company, has been formed for the Building of Houses suitable in every respect for the accommodation of Masters and Pupils. The Houses are to be built to hold not less than Thirty or more than Forty Pupils, upon the condition that the College Company have the power of pre-emption of the same within Ten Years at the Cost Price; and it is also agreed that if the Plans, Elevations, and Estimates are approved by the Council of the College they will guarantee to the Building Company 6 per cent upon the outlay.

The Capital of the Malvern College Building Company (Limited) is to be **£15,000**, in Shares of **£100** each, of which **£3,700** has already been subscribed; and in the disposal of these Shares a preference will be given to the Proprietors of the College Company. If, therefore, you would like to avail yourself of this opportunity of assisting the College Company, and at the same time of making so favourable an investment, be pleased, within the next Ten Days, to fill up the enclosed application and forward the same to the Secretary of the Malvern College Building Company, Great Malvern.

I am,

Your most obedient Servant,

HENRY ALDRICH,

SECRETARY.

To *Chas Turner Cooke Esq.*
26 Cambray Place
Cheltenham.

The Malvern College Building Company Ltd.
An arrangement had to be made for a second company to finance the building of boarding houses.

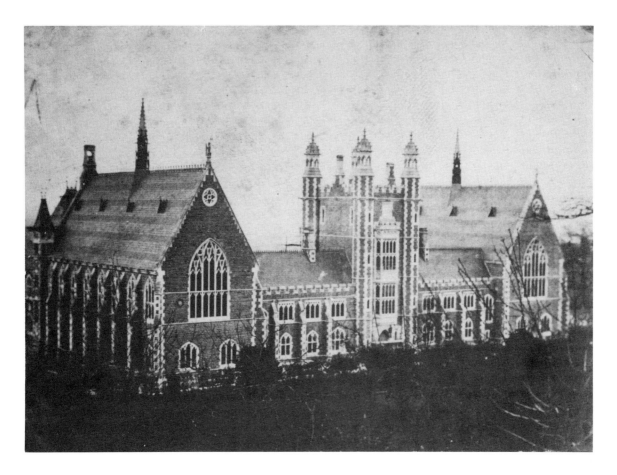

THE MALVERN NEWS AND JOURNAL,

WEDNESDAY, JULY 29, 1863.

THE PROPRIETARY COLLEGE.

The formal laying of the ceremonial stone of the building for the new college took place on Wednesday last, and was quite an event in Malvern. For this ceremonial the Council, assisted by their indefatigable honorary secretary, Dr. Stummes, made all the necessary arrangements at the site of the building in the Radnor-road. To give the visitors an idea of the magnitude of the college, standards were erected, one at each corner of the site. These were ornamented with evergreens and flags at the top. The part of the building where the first stone was laid was at the north-west angle.

The College from the West. The foundation stone was laid by the Bishop of Worcester on 22nd July, 1863, but the school was not ready to receive the first boys for eighteen months, three months behind schedule. Note in this early photograph there is not yet a clock in place.

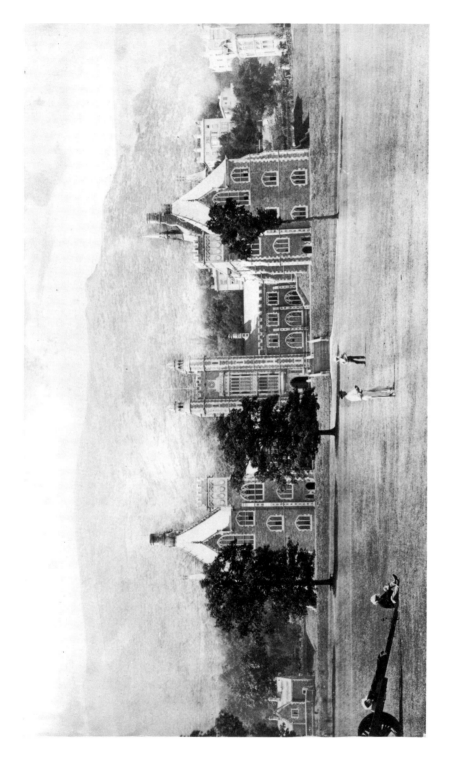

This eastern view dates from the early 1870s, before the levelling of The Senior. The Lodge, which is now masked by the Chapel can clearly be seen on the left and Malvernbury stands out on the right: this was for a time the home of both No 6 and No. 9. School house on the extreme right has not yet been extended.

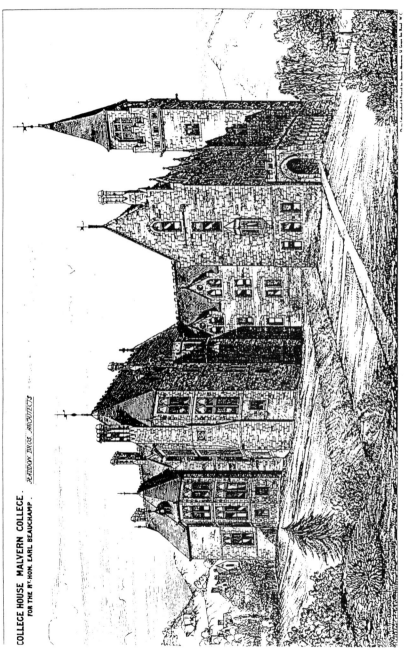

THE BUILDING NEWS, JUNE 25. 1875.

COLLEGE HOUSE MALVERN COLLEGE.
FOR THE Rt HON. EARL BEAUCHAMP.

HADDON BROS. ARCHITECTS.

The architect's drawing of the extension to School House. Lord Beauchamp who owned School House, agreed to and financed an extension to the building, originally built as the Headmaster's private residence. It was planned that the extra space would house seventy boys, and the headmaster was to be the Housemaster.

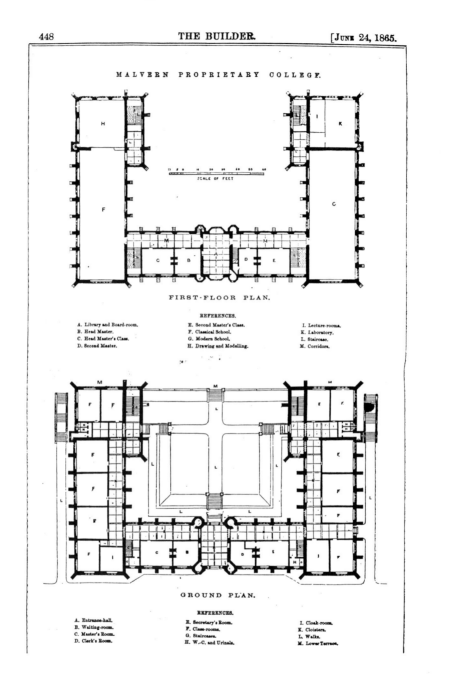

MALVERN PROPRIETARY COLLEGE.

SCALE OF FEET

FIRST-FLOOR PLAN.

REFERENCES.

A. Library and Board-room. E. Second Master's Class. I. Lecture-rooms.
B. Head Master. F. Classical School. K. Laboratory.
C. Head Master's Class. G. Modern School. L. Staircase.
D. Second Master. H. Drawing and Modelling. M. Corridors.

GROUND PLAN.

REFERENCES.

A. Entrance-hall. E. Secretary's Room. I. Cloak-room.
B. Waiting-room. F. Class-rooms. K. Cloisters.
C. Master's Room. G. Staircases. L. Walks.
D. Clerk's Room. H. W.-C. and Urinals. M. Lower Terrace.

It is interesting to note that the Headmaster's Study is still sited in the same room as shown in this early plan.

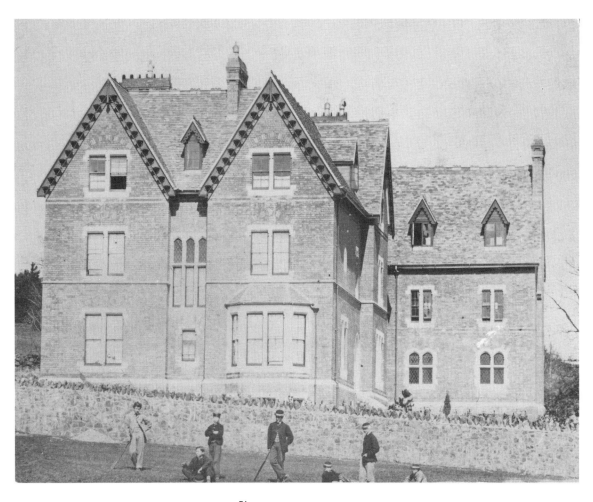

No 1

Twenty six boys joined the school on 25th January 1865 eleven were day boys, or 'home boarders', the remainder were divided between No. 1 and No. 2. The boarders awoke on the first morning to see a thick covering of snow outside and they had to dig their way to the main building. This early photograph shows that there has been little change on the south and east of No.1.

No 1: Cubicles

It was a feature at Malvern until the last war that nearly all boys slept in the privacy of their own cubicles. There was one cold and one hot tap on each floor. In the first cubicle on the left a hand wash basin may be seen. Judging by the fire guard there must have been the occasional open fire.

No 1: Dining Hall
This photograph was taken shortly after the first world war. The benches, chairs and tables are still in use, although they were temporarily lost during the last war. H.C.W. Wilson who reopened No. 1 in 1946 eventually traced them, stored in an old cinema in Worcester along with much other furniture from the college. He was also responsible for the oak panelling which now adorns this room.

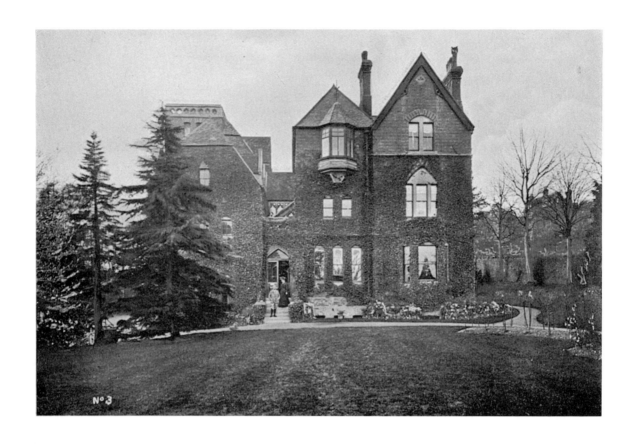

No 3
No. 3 was opened in 1867 followed the next year by No. 4 and by No. 5 in 1871.No. 6 received the first boys in Malvernbury twenty years later, the remaining three Houses opened in quick succession, No. 7 in 1892, 8 in 1895 and 9 in 1898.

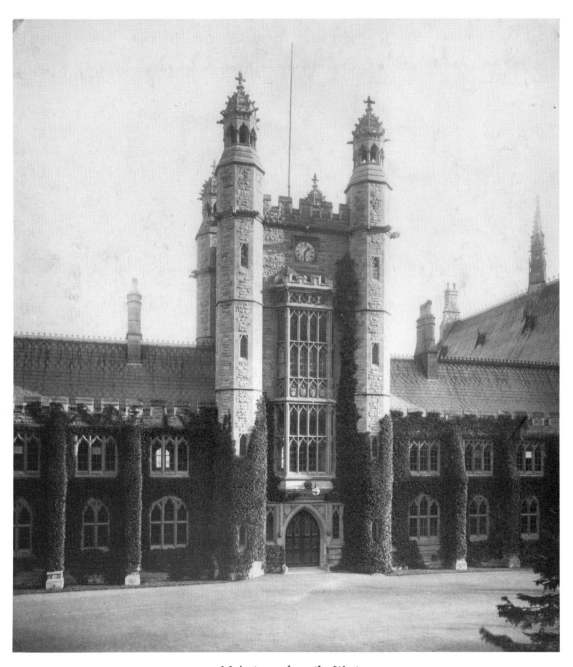

Main tower from the West

Taken in the eighteen eighties this photograph illustrates a number of features which have long since gone, the embellishments on the cupolas, the gargoyles just above the level of the clock, the spire on the south wing and the attractive light over the door. The ivy which eventually did serious damage to the stonework was removed in the early thirties.

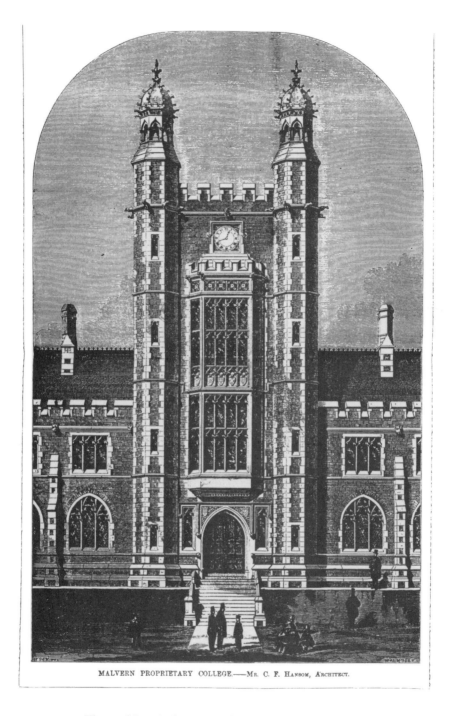

MALVERN PROPRIETARY COLLEGE.——Mr. C. F. Hansom, Architect.

The architect's drawing of the tower from the east.

The Council Room
This classroom was later panelled in memory of Charles Toppin. The Toppin Room is now part of the Common Room complex.

The Prefects' Room.

This was originally the College Clerk's room but within ten years became the Prefects' Room, a function which it retained until January 1990.

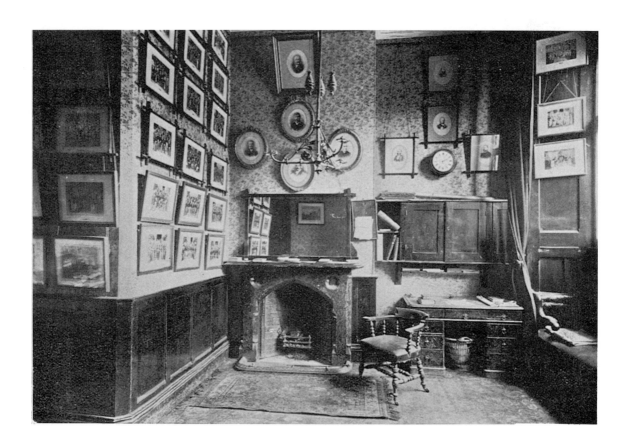

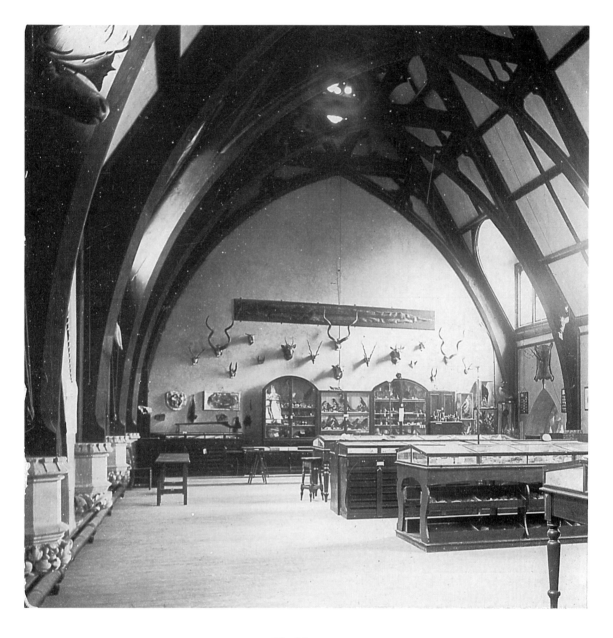

The Museum.

The upper floor in the South wing of the main building was originally set aside as the Sanatorium. Housemasters were expected to pay six shillings and eightpence per boy per term towards its running costs. In the nineties the Sanatorium was moved to rented accommodation in the Lees, awaiting the construction of the large purpose built building in St Andrew's Road which took place in 1893. Part of the first Sanatorium became the museum, until it was needed as an art school.

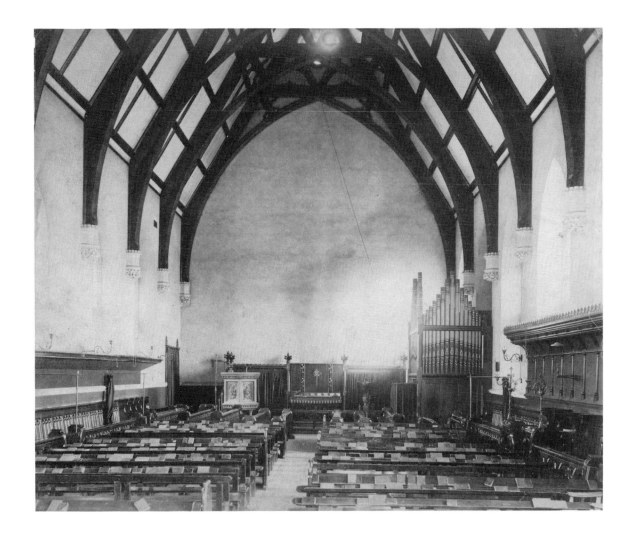

The old chapel in the south wing. Masters and wives sat under the canopy on the left. The pulpit was later given to the College Mission Chapel in Dockland. Notice the gas lighting. The lectern is brought into occasional use in todays chapel.

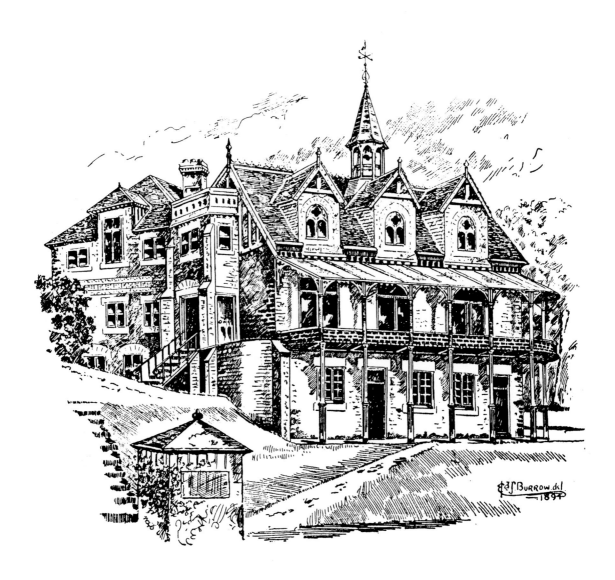

The Pavilion Block

The pavilion block, built in 1877, has seen more changes than any other building in the grounds. It was originally constructed to include the gymnasium, workshops, laboratory, fives courts and grubshop. The Grub was situated round the right hand corner and was only replaced in 1927.

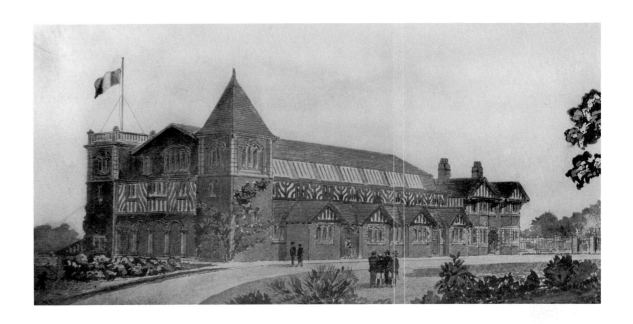

The Gymnasium, was built in 1903, the whole complex included as it does today South Lodge, the new fives courts, and the College store. Until the building of the Sports Hall the Gymnasium doubled as a theatre. The new rackets court was built at the same time and can be seen on the right.

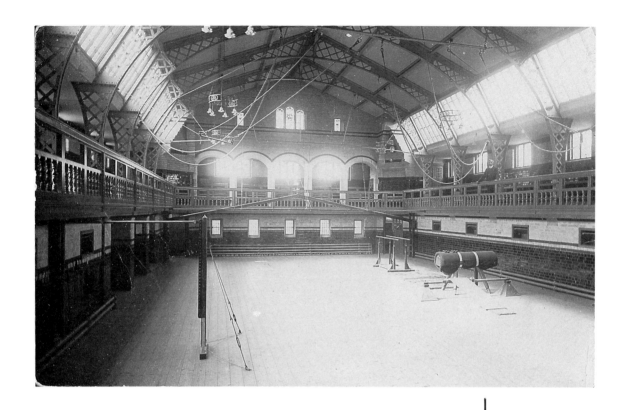

Gym interior. Photograph taken early in the century.

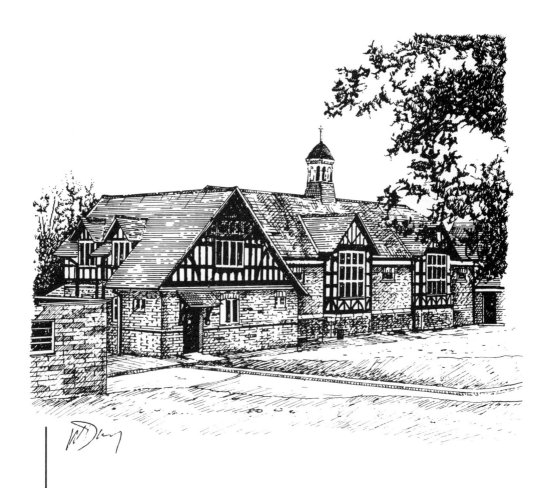

The Swimming Pool. This was built in 1892. Prior to its construction arrangements were made for boys to swim at New Pool across the common.

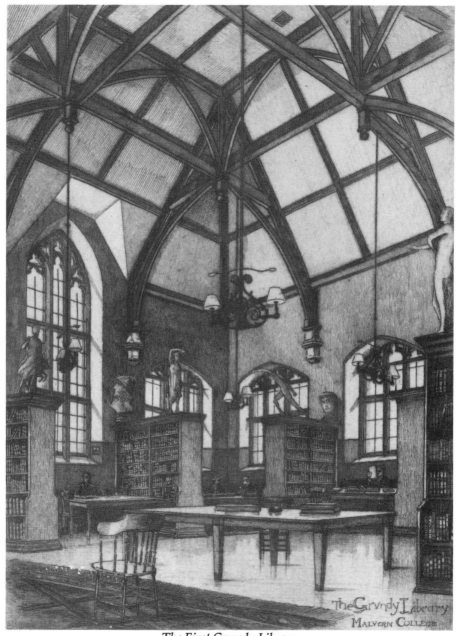

The First Grundy Library

After the death of the Rev. W. Grundy in 1891, a subscription list made it possible to open the first school library which was given his name, a termly subscription of one shilling was made on the bill. Following a fire in this room in 1956 the 'Grundy' was moved to its present site and the room in the drawing now makes up the economics and careers area. This picture is from an etching by E.J. Burrow.

31

Carving

MALVERN COLLEGE.

OCTOBER 22ND. 1902.

DEDICATION

OF

THE EAST WINDOW

AND OF

THE SEDILIA.

I. ORDER OF SERVICE.
II. LIST OF OLD MALVERNIANS WHO FELL IN THE WAR.
III. DESCRIPTION OF THE WINDOW.
IV. INSCRIPTION FOR THE SEDILIA.

Angelic Donors

1. H. Kempson
2. G. H. Blore
3. Mary Joyce
4. H. H. House
George
G. W. U.

THE

FORM OF PRAYER

AND

CEREMONIES

TO BE USED AT THE

Dedication of the Chapel

OF

Malvern College,

On FRIDAY, JUNE 23rd, 1899.

BY AUTHORITY.

The chapel designed by Sir Arthur Blomfield was first used in an incomplete state in 1899. Notice in the 1900 drawing there is not yet panelling on the walls, nor are the oak pews yet in place. An interesting feature is that the twelve carved angels amongst the roof timbers, were completed early on the advice of the architect, to avoid the later expense of scaffolding. In modern parlance, private sponsorship was sought for each angel and was quickly forthcoming. Note the clear glass. Artistic licence no doubt prompted E.J. Burrow to sketch in the reredos; this followed much later.

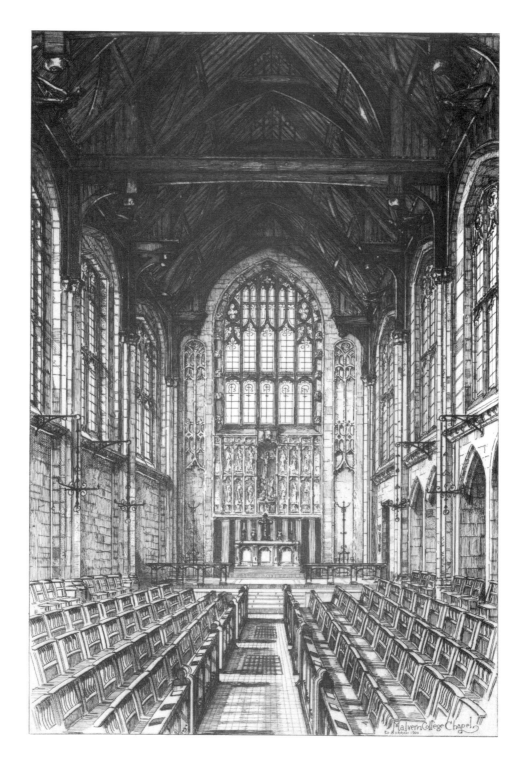

Malvern College Chapel
E. B. Varrow 1900

For the Erection and Completion of
Malvern College Chapel,
Malvern, Worcestershire.

To
 Sir Arthur W. Blomfield, A.R.A. & Sons,
 Architects.

Dear Sirs,

We are willing to execute the above mentioned Works according to the Drawings and Specification prepared by you and complete the same to your satisfaction for the sum of Eight Thousand Four hundred and Sixty Eight pounds £8,468.0.0

We are, dear Sirs,
Yours, obediently,

Name Collins & Godfrey

Address Tewkesbury

Date 18 April 1896

.......... further estimate the cost of the Separate Works as follow :—

	£.	s.	d.
(1) Floors	596	0	0
(2) Glazing, casements, condensation gutters, saddle bars & stancheons	392	0	0
(3) Doors and Ironmongery	96	0	0
(4) External steps &c. at N.E. corner of Chapel	102	0	0
(5) Lightning Conductor	12	0	0
	£1198		over

The tender for construction of the Chapel

34

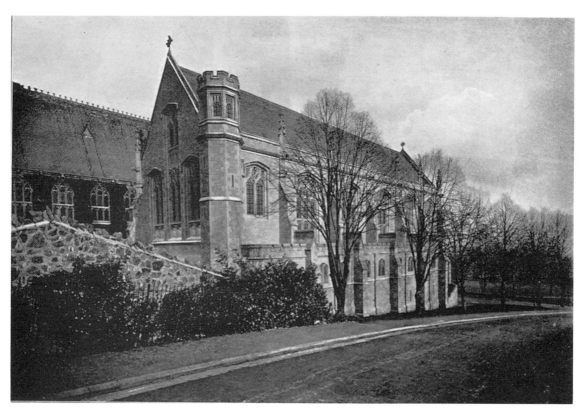

The exterior view of the chapel above shows the building before the construction of the 'rabbit hutches'. This later extension followed in 1908 to accommodate the growing numbers in the school, it was designed by C.J. Blomfield, son of Sir Arthur, and is well illustrated in Bill Denny's drawing.

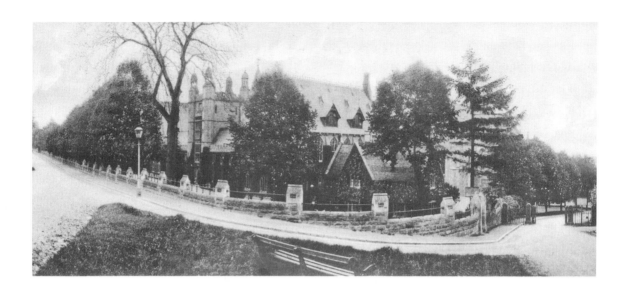

Two panoramic views early in the twentieth century.

MASTERS AND BOYS

———

———

'The Early Bird' The Rev. Arthur Faber.

The Reverend Arthur Faber 1865-1880 was Malvern's first Headmaster. He was paid the very considerable salary of £800 a year, with an extra £200 until the number of boys in the school reached 400, which it never did in his time. He was a Wykehamist and in many ways tried to model Malvern on his old school. Malvern was indeed fortunate that he was the first Headmaster; he was liked and admired by boys, masters and parents and when he retired an exhibition was founded in his name. Later his Headmastership was commemorated by the Faber gate at the top of Woodshears Road and by the Epiphany window in the chapel. There were 274 boys in the school when he retired.

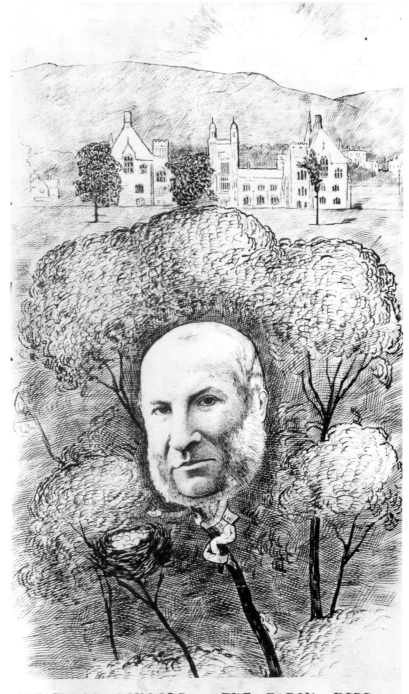

OUR PUBLIC SCHOOLS. THE EARLY BIRD.

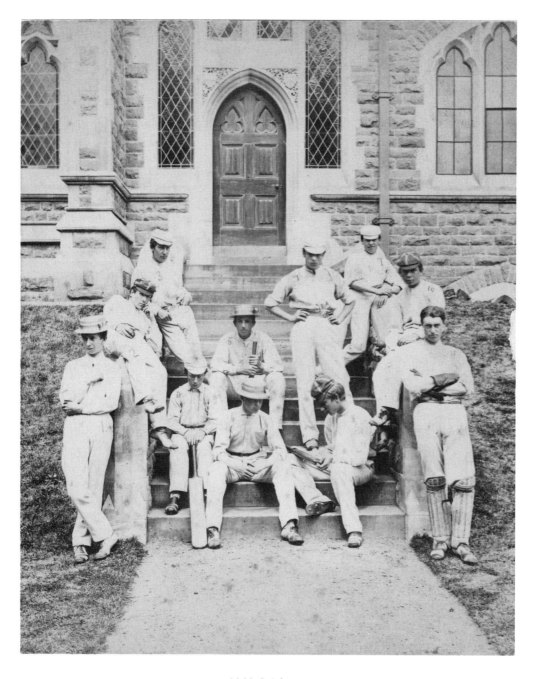

1868 Cricket XI
Four years before the first levelling of the Senior. The white caps were worn by new members of
the XI.

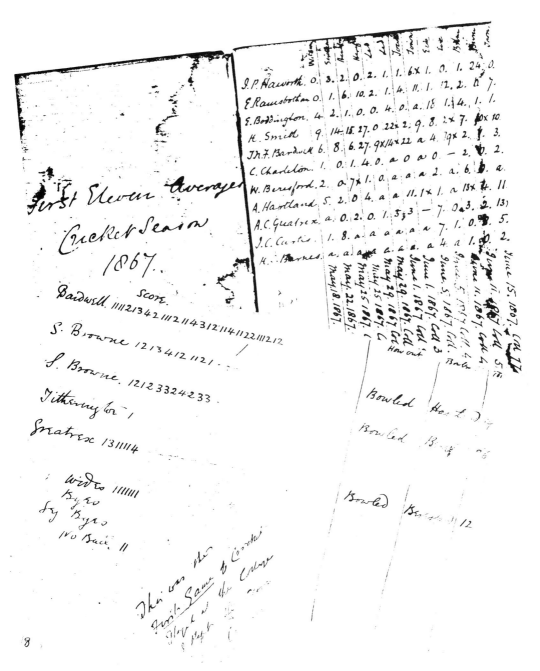

Until the Senior was levelled Malvern had a distinct advantage over their opponents, nonetheless matches were played from the outset, as this extract from an 1866 score sheet and the averages from 1867 show.

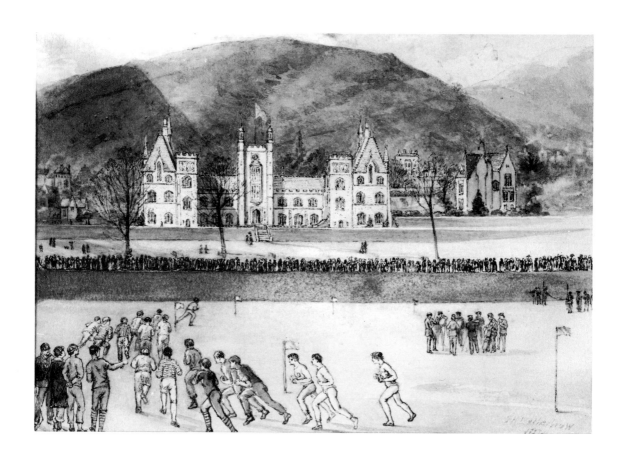

Malvern College Sports 1874
The Sports Days were clearly
important occasions. It is worth
noting that School House had not
yet been extended and Malvern-
bury can be clearly seen to the
right of the main building. On
the 1875 programme there is no
school coat of arms, just a
monogram. The coat of arms
designed by Sir Edward
Lechemere was adopted in 1877.

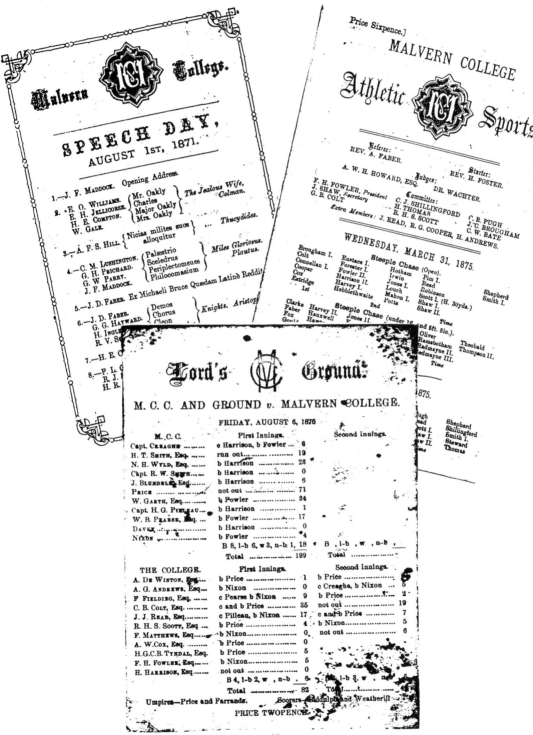

Malvern College.

SPEECH DAY,
AUGUST 1ST, 1871.

1.—J. F. MADDOCK. Opening Address.

2.— E. O. WILLIAMS. { Mr. Oakly
E. H. JELLICORSE. { Charles
H. E. COMPTON. { Major Oakly
W. GALE. { Mrs. Oakly } *The Jealous Wife,*
Colman.

3.— A. F. S. HILL { Nicias milites suos ... *Thucydides.*
alloquitur

4.—C. M. LUSHINGTON. { Palæstrio
G. H. PRICHARD. { Sceledrus
G. W PARRY. { Periplectomenes } *Miles Gloriosus.*
J. F. MADDOCK. { Philocomasium } *Plautus.*

5.—J. D. FABER. Ex Michaeli Bruce Quædam Latinè Reddit.

6.—J. D. FABER. { Demos
G. G. HAYWARD. { Chorus } *Knights. Aristoph.*
H. INGL { Cleon
R. V. S

7.—H. E. C

8.— F. L
R. J.
H. R.

MALVERN COLLEGE
Athletic Sports.

Selette:
REV. A. FABER.

Judges:
A. W. H. HOWARD, ESQ.
DR. WACHTER.

Starter:
REV. H. FOSTER.

F. H. FOWLER, *President*
J. SHAW, *Secretary*
G. B. COLT.

Committee:
C. J. SHILLINGFORD
H. THOMAS
R. H. S. SCOTT

C. R. PUGH
J. C. BROUGHAM
C. W. BATE

Extra Members: J. READ, E. G. COOPER, H. ANDREWS.

WEDNESDAY, MARCH 31, 1875.

Brougham I.
Colt
Connellan I.
Cooper
Cox
Patridge
1st

Steeple Chase (Open).

Eustace I.
Forester I.
Fowler II.
Harrison II.
Harvey I.
Hebblethwaite

Hotham
Irwin
Jones I.
Louch
Mahon I.
Potts

Pim I.
Read
Robinson
Scott I. (H. 30yds.)
Shaw I.
Shaw II.

Shepherd
Smith I.

Clarke
Faber
Fox

Steeple Chase (under 16

Harvey II.
Hauxwell
Haw

Jones II.
Time

and 5ft. 5in.)
Oliver
Ramsbotham
Radmayne II.
Redmayne III.
Time

Theobald
Thompson II.

Shepherd
Shillingford
Smith I.
Steward
Thomas

1875.

Lord's Ground
M. C. C. AND GROUND v. MALVERN COLLEGE.

FRIDAY, AUGUST 6, 1875

M.C.C.	First Innings.		Second Innings.
Capt. CREAGHE	c Harrison, b Fowler	6	
H. T. SMITH, Esq.	run out	19	
N. H. WYLD, Esq.	b Harrison	28	
Capt. R. W. SMITH	b Harrison	0	
J. BLUNDELL, Esq.	b Harrison	6	
PRICE	not out	71	
W. GARTH, Esq.	b Fowler	34	
Capt. H. G. PILLEAU	b Harrison	1	
W. B. PEARSE, Esq.	b Fowler	17	
DAVEY	b Harrison	0	
NIXON	b Fowler	4	
	B 8, l-b 6, w 3, n-b 1,	18	B , l-b , w , n-b
	Total	199	Total

THE COLLEGE.	First Innings.		Second Innings.	
A. DE WINTON, Esq.	b Price	1	b Price	5
A. G. ANDREWS, Esq.	b Nixon	0	c Creaghe, b Nixon	5
F FIELDING, Esq.	c Pearse b Nixon	9	b Price	2
C. B. COLT, Esq.	c and b Price	35	not out	19
J. J. READ, Esq.	c Pilleau, b Nixon	17	c and b Price	7
R. H. S. SCOTT, Esq	b Price	4	b Nixon	5
F. MATTHEWS, Esq.	b Nixon	0	not out	6
A. W. COX, Esq.	b Price	0		
H.G.C.B. TYNDAL, Esq.	b Price			
F. H. FOWLER, Esq.	b Nixon	5		
H. HARRISON, Esq.	not out	0		
	B 4, l-b 2, w , n-b	6	B , l-b 3, w ,	
	Total	82	Total	

Umpires—Price and Farrands. Scorers—Biddulph and Weatherill

PRICE TWOPENCE.

43

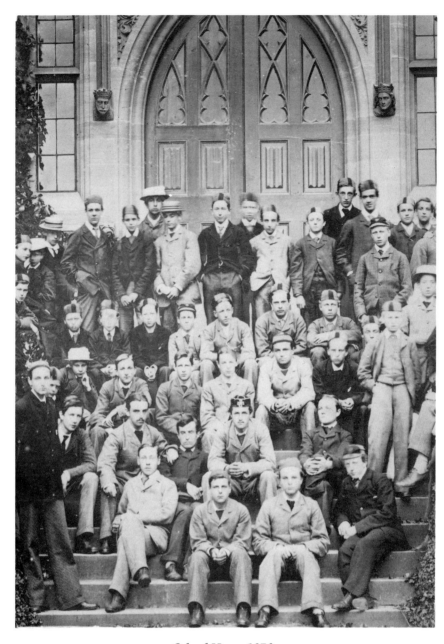

School House 1876

In 1871 Faber became Housemaster of School House in the building which is now No. 3. In 1877 School House was moved to its present home. The House had been considerably enlarged, but still remained the property of Lord Beauchamp. The school was not in a position to buy it. After some unhappy legal proceedings it was finally bought by the Malvernian Society for £13,500.

Some extracts from the Malvern College Roll, the forerunner to the Red Book which started in 1902.

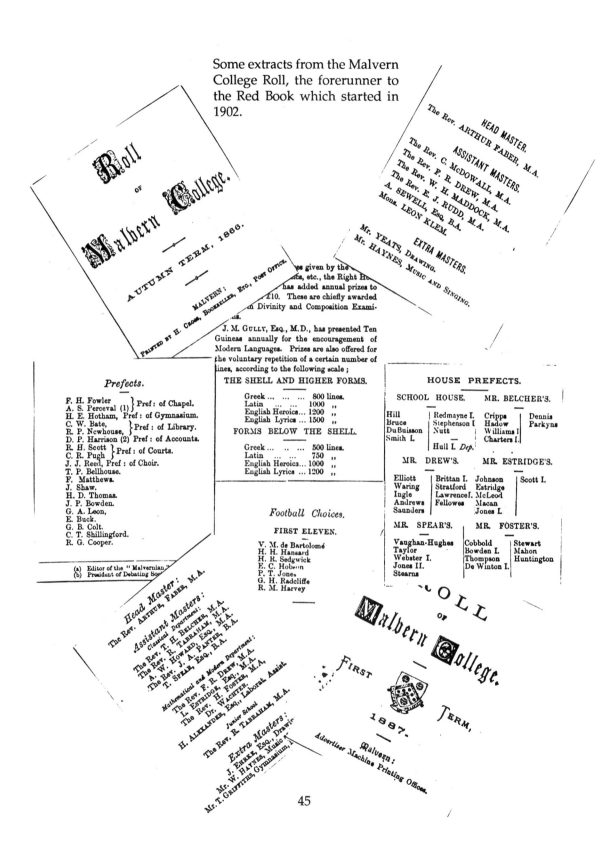

Roll
OF
Malvern College.

AUTUMN TERM, 1886.

MALVERN:
PRINTED BY H. CROSS, BOOKSELLER, ETC., POST OFFICE.

The Rev. ARTHUR FABER, M.A. HEAD MASTER.

ASSISTANT MASTERS.
The Rev. C. McDOWALL, M.A.
The Rev. F. R. DREW, M.A.
The Rev. W. H. MADDOCK, M.A.
The Rev. E. J. RUDD, M.A.
A. SEWELL, ESQ, B.A.
Mons. LEON KLEM.

EXTRA MASTERS.
Mr. YEATS, DRAWING.
Mr. HAYNES, MUSIC AND SINGING.

...es given by the
...s, etc., the Right Ho...
...has added annual prizes to
...£10. These are chiefly awarded
...n Divinity and Composition Exami-
...s.

J. M. GULLY, Esq., M.D., has presented Ten Guineas annually for the encouragement of Modern Languages. Prizes are also offered for the voluntary repetition of a certain number of lines, according to the following scale;

THE SHELL AND HIGHER FORMS.

Greek 800 lines.
Latin 1000 ,,
English Heroics... 1200 ,,
English Lyrics ... 1500 ,,

FORMS BELOW THE SHELL.

Greek 500 lines.
Latin 750 ,,
English Heroics... 1000 ,,
English Lyrics ... 1200 ,,

Prefects.

F. H. Fowler } Pref: of Chapel.
A. S. Perceval (1)
H. E. Hotham, Pref: of Gymnasium.
C. W. Bate, } Pref: of Library.
R. P. Newhouse,
D. P. Harrison (2) Pref: of Accounts.
R. H. Scott } Pref: of Courts.
C. R. Pugh
J. J. Reed, Pref: of Choir.
T. P. Bellhouse.
F. Matthews.
J. Shaw.
H. D. Thomas.
J. P. Bowden.
G. A. Leon,
E. Buck.
G. B. Colt.
C. T. Shillingford.
R. G. Cooper.

(a) Editor of the " Malvernian"
(b) President of Debating Soc...

Football Choices.

FIRST ELEVEN.

V. M. de Bartolomé
H. H. Hansard
H. R. Sedgwick
E. C. Hobson
P. T. Jones
G. H. Radcliffe
R. M. Harvey

HOUSE PREFECTS.

SCHOOL HOUSE.		MR. BELCHER'S.	
Hill	Redmayne I.	Cripps	Dennis
Bruce	Stephenson I	Hadow	Parkyns
DuBuisson	Nutt	Williams I	
Smith L	—	Charters I.	
	Hull I. Dep.		

MR. DREW'S.		MR. ESTRIDGE'S.	
Elliott	Brittan I.	Johnson	Scott I.
Waring	Stratford	Estridge	
Ingle	Lawrence I.	McLeod	
Andrews	Fellowes	Macan	
Saunders		Jones L	

MR. SPEAR'S.		MR. FOSTER'S.	
Vaughan-Hughes		Cobbold	Stewart
Taylor		Bowden L	Mahon
Webster I.		Thompson	Huntington
Jones II.		De Winton I.	
Stearns			

ROLL
OF
Malvern College.

FIRST TERM, 1887.

MALVERN:
Advertiser Machine Printing Offices,

Head Master:
The Rev. ARTHUR FABER, M.A.

Assistant Masters:
Classical Department:
The Rev. T. H. BELCHER, M.A.
The Rev. R. TABRAHAM, M.A.
A. W. HOWARD, ESQ., M.A.
The Rev. J. A. PANTER, B.A.
T. SPEAR, ESQ., B.A.

Mathematical and Modern Department:
The Rev. F. R. DREW, M.A.
L. ESTRIDGE, ESQ., M.A.
The Rev. H. FOSTER, M.A.
Dr. WACHTER.
H. ALEXANDER, ESQ., Laborat. Assist.

Junior School:
The Rev. R. TABRAHAM, M.A.

Extra Masters:
J. EHRKE, ESQ., Drawing.
Mr. W. HAYNES, Music
Mr. T. GRIFFITHS, Gymnasium, ...

45

1873.

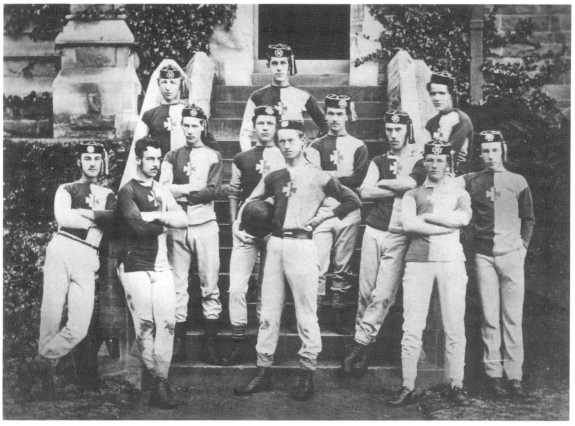

G.G.White. O.R.Coote. C.S.Cox.

H.E.Hotham. T.E.Vaughan. E.L.Childe-Freeman. T.R.Vickers.

C.H.Sutton. D.P.Ware. A.H.Stratford. W.M.Tomlinson. C.E.Newill.

Association Football

The rules of Association Football were drawn
up in 1863 by a committee of Old Boys from
schools which had not taken to the running
game of Rugby. Malvern College went a long
way towards adopting Association rules but
not entirely, as can be seen on the opposite
page. Association rules were adopted the
following year.

MALVERN FOOTBALL RULES 1873

I. – The length of the ground shall not be more than 120 yards, and the breadth not more than 100 yards. The ground shall be marked out by posts, and two posts shall be placed on each Goal Line at a distance of 25 yards from each Goal Post.

II. – The choice of Goals is determined by tossing, the losing side taking kick off at a distance of 25 yards from Goal Line.

III. – In a match, when half the time agreed upon has elapsed, the sides shall change ends when the ball is next out of play. After the change, the ball must be kicked off from 25 yards in the same direction as at first. And after a Goal, the ball shall be kicked from the 25 yards' post by the side losing it.

IV. – When a player has kicked the ball, any one of the same side, who is nearer to the opposite Goal Line is tag (out of play), and may not touch the ball himself. A player in tag comes out of tag as soon as any one has kicked or stopped the ball, or when one of his own side has passed him with the ball.

V. – When the ball goes out of the ground by crossing the side lines it is out of play, and shall be thrown straight in again at the point at which it went out, between the two lines of players, and shall not be in play till it shall have touched the ground.

VI. – When the ball goes out of the ground by crossing the Goal Line, it shall be kicked out from behind the Goal Line.

VII. – That there be no handling, catching, or throwing the ball by any player, except the Goal Keeper, and then only to save his Goal.

VIII. – A Goal is obtained when the ball goes out of the ground by passing between the Goal Posts, or in such a manner that it would have passed between, had they been of sufficient height.

IX. – That the ball, when in play, may be stopped by any part of the body except the hands.

X. – All charging is fair; but holding, pushing with the hands, tripping up, and hacking, are forbidden.

XI. – In case a player infringe any rule, the ball shall be taken to the side line, nearest to the point at which the infringement occurred and thrown straight in again according to rule 5.

XII. – In every case the decision of the Referee or Umpires shall be final.

A.H.S.

Printed at the "Advertiser" Office, Malvern

The Rev. C.T. Cruttwell.

Mr. Cruttwell had been headmaster of Bradfield. In this picture some of the Bradfield buildings make up the background. Though a fine scholar and sportsman his Headmastership was scarred by an unhappy and protracted disagreement with the Rev. F.R. Drew, Housemaster of No. 2. Following the inevitable dismissal of the latter, numbers tumbled, no less than twenty eight were prematurely withdrawn from No. 2. Cruttwell resigned after five years and took a living in Sutton.

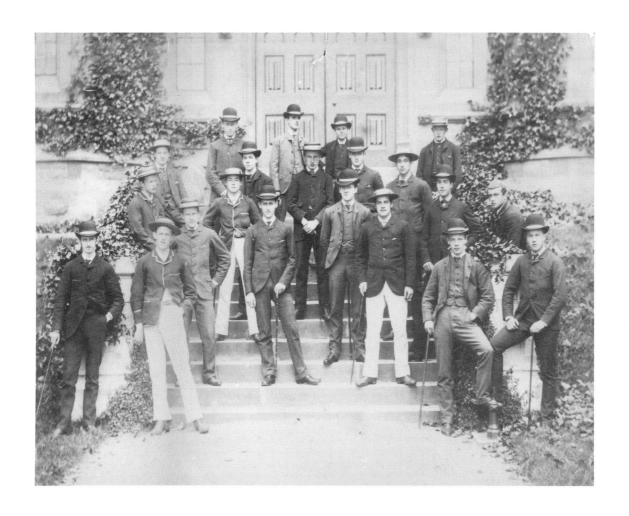

1881 School Prefects

The Rev. W. Grundy

The Reverend W. Grundy like his predecessors was in his thirties, he had for five years been Headmaster of Warwick School, and also following in their footsteps he was a distinguished scholar and athlete. He had the reputation of being a severe disciplinarian. He died in office in 1891, only six years after becoming Headmaster. He raised the numbers from 188, the level to which they had dropped, to 323.

1 Upper Brook St.
London W.
Jan 23rd 1885

To the Governors of Malvern College

My Lords and Gentlemen.

I have been asked by the Rev. William Grundy. to write to you with regard to his application for the HeadMastership of Malvern College. I have been intimately acquainted with Mr Grundy for the last ten years and from what I know of him I feel the strongest confidence in giving an opinion that he is – speaking merely on general grounds – admirably qualified for the post.

More particularly I would draw your attention to the rapid rise of the Kings School Warwick; since Mr Grundy became Head Master now just four years ago. During that time the numbers have almost trebled, a most remarkable fact considering the neglected and disorganized state of the school when he took charge of it, and the strong educational competition in the immediate neighbourhood.

An extract from a letter recommending Rev. W. Grundy

51

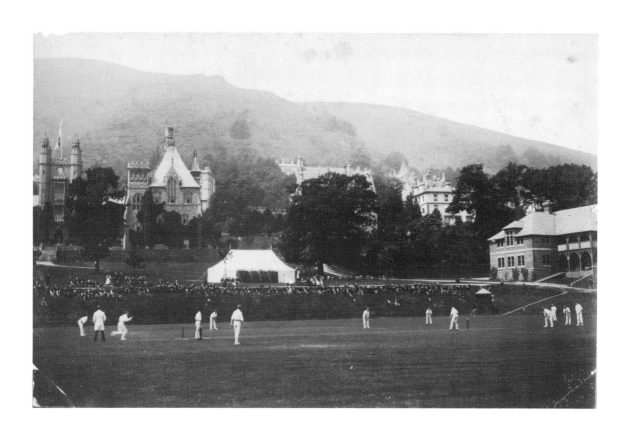

Malvern v Rossall June 19th, 20th 1891
This was the last time Malvern played Rossall.
The match was won by an innings and 149 runs.
P.H. Latham who is fielding at cover made 214
for Malvern. Note the old gallery to the pavilion.

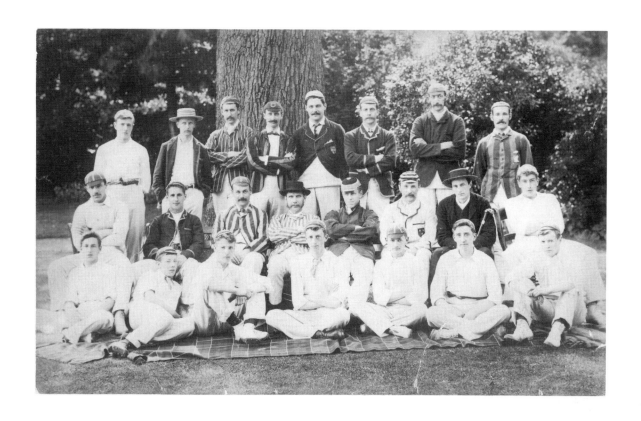

Masters v Boys 1891

Back row: H.K. Foster, H.H. House, L.S. Milward, E.C. Bullock, - , Dr Brockatt, P.H. Foley,
C.T. Salisbury.
Middle row: G.A. Mitchell, P.H. Latham, R.E. Lyon, Rev W. Grundy, C. Toppin, H.M. Faber,
H.E. Huntington, C.A.H. Ransome.
Front row: J.C. Swinburne, T.B. Rhodes, F.W. Ramsey, W.W. Lowe, H.S. Pike, C.J. Jones,
W.L. Foster.

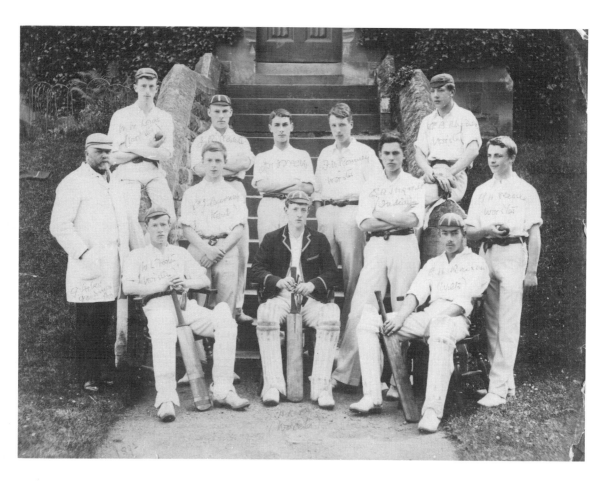

Dear Webb

I am writing to tell you that you may have your 1st XI colours. And I hope that you always play up hard & keep up the reputation of having been in one of the best teams we have ever had.

Ever yrs

Harry. Foster

Cricket XI 1892
This fine XI actually took the field during the period of an interregnum when the Reverend H. Foster took control after Grundy's death. Two of his sons were in the side. In the two school matches played, they beat Repton by an innings and Sherborne by 10 wickets. The letter is from H.K. Foster the Captain to J.J. Webb.

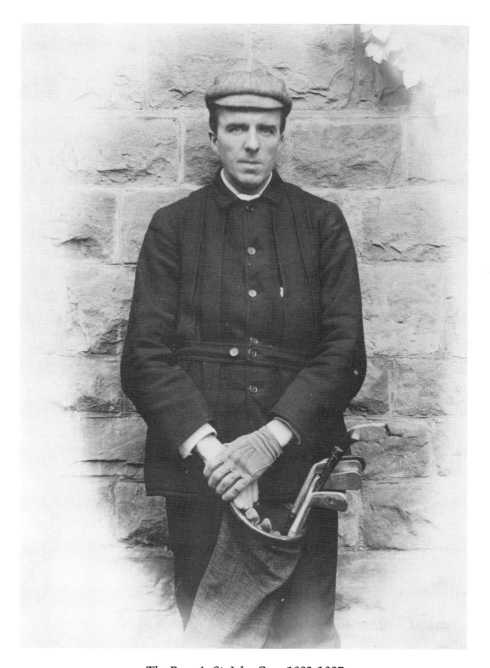

The Rev. A. St. John Gray 1892-1897

A. St. John Gray the fourth Headmaster only held office for a short period having to resign through ill health, although he lived on to be 84. It was his drive and inspiration which led to the building of the chapel.

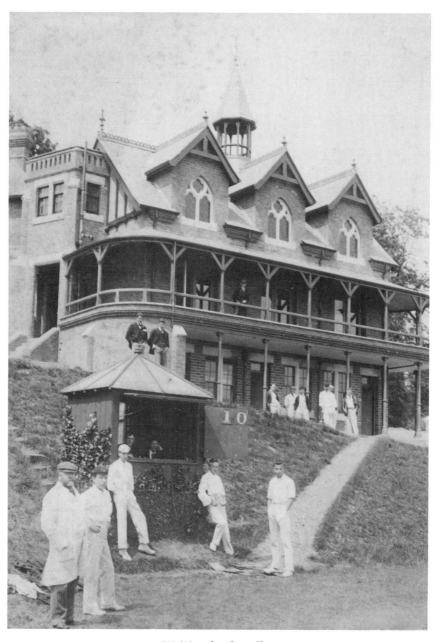

Waiting for the roller

Waiting for the roller to come off in 1895. Note that the pavilion has been altered. The figure on the left is George Arber who had come as cricket professional in 1869. He owned and ran the first College Store in No. 1 The Lees and setting up as a builder was responsible for the construction of the houses which circle the Lees Field.

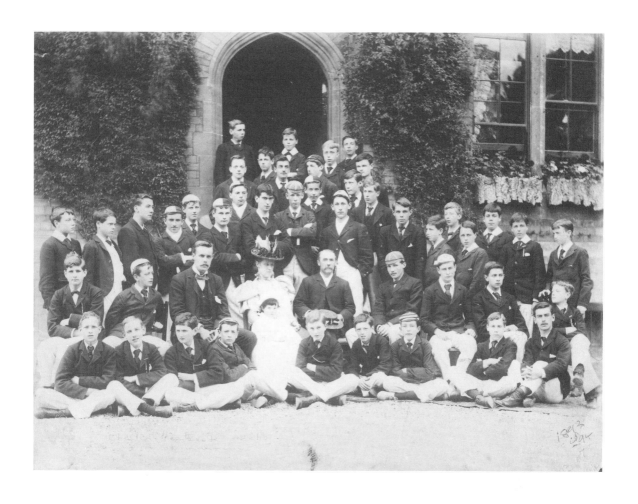

No. 1 House Group 1896 in the time of Rev. H.M. Faber
a nephew of the first Headmaster.

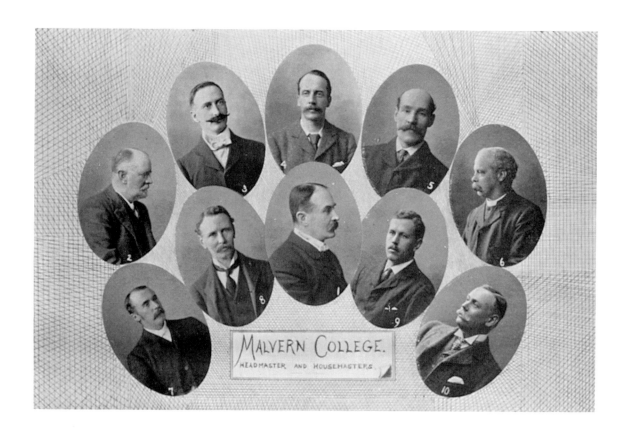

S.R. James 1897-1914 with his Housemasters

The good hearted, games playing extrovert who averaged four rounds of golf a week. S.R. James, came to Malvern from Eton where he had been a Housemaster for eight years. The reputation of Malvern as a games school was largely established during his seventeen year term. During this period amongst many fine cricketers, the last four Fosters, the Day and Naumann brothers, Donald Knight, Frank Mann and W.H.B. Evans benefited from his encouragement and from the guidance of Charles Toppin, W.H.B. Evans is remembered by the Advent window in the chapel following his death in 1913 when flying with Colonel Cody.

Amongst the Housemasters surrounding the Headmaster in this picture are some of Malvern's greatest characters.

The Rev. Henry Foster was the driving force behind games in the school from 1867-1915. He was largely responsible for the first Rackets Court in 1881 and for the construction of the Swimming Pool in 1892. For a time he was in charge of music and was responsible for starting the Corps in 1883. As second master, he was twice called upon to act as Headmaster.

E.C. Bullock also had a term as acting Headmaster. He was said to be an inspired teacher of the army side.

C.T. Salisbury opened No. 8 in Malvernhurst in 1903, moved to Malvernbury and finally to Radnor House in 1906.

H.H. House was a much loved teacher, the classical VIth Form room is panelled in his memory.

R.E. Lyon was the Housemaster to start No. 7, he was director of music, being the composer of the music for The Carmen. He not only ran the corps but himself raised and commanded the 2nd South Midland Battalion of the Territorial Army in 1915. The Lyon Room in the Monastery was panelled in his memory.

Charles Toppin will best be remembered for the string of fine cricketers that passed through his hands. It is true that he was lucky to have the talent and gifts of the Fosters and Days upon which to work, but there is no doubting his remarkable ability to get the best out of even ordinary cricketers. He was a powerful character in the Common Room where today the principal room bears his name.

No. 4 winners of the Swimming Cup 1903
Note, the watch chains, the boots and the Eton collar

L.R. Greene R.T. Jones G.A. Clarkson
P.F. Lark J.J.E.B. Stewart

R.B. Porch in No. 6 Yard 1901

Judy Porch is another of Malvern's great names. An old boy of the school he later became Housemaster of No. 3 1919-33. The steps up to the main building were named in his honour at the time of the centenary. Note the old crocketts bat, these were specially made and could be bought in the Store.

G.N. Foster 1904. This photograph shows the single rackets court, the second was built the following year. It is also worth noting the sail-cloth sight screen.

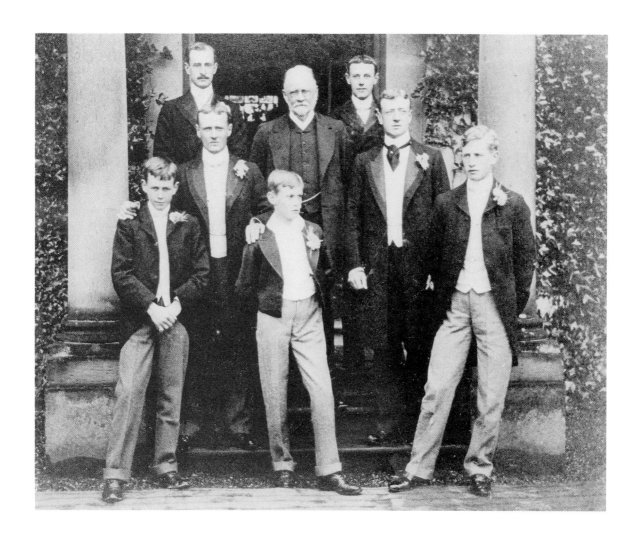

The Rev. Henry Foster and his seven sons. 1905.

R.E.	Rev. Henry	B.S.
W.L.		H.K.
M.K.	N.J.A.	G.N.

Some notices from S.R. James to the School

To invigilating masters
Examinations

The Senior master on duty should be in the Big School when the doors are opened. I am told there has been some ragging.

To ... masters.

Papers ... any other external

exam ... Bosser or

... mmon room

Boys are reminded that no books must be left in the corridors or Elsewere about the Buildings

Feb 16th 1900
Kimberly relieved by French yesterday. Official

Noon March 5th.
Half Holiday for the relief of Ladysmith.

June 12th 1900.
During the hot weather boys must not sit in the Sun without wearing hats or caps

Concert Thursday 14th Feb by the

Boys will enter the Assembly Rooms

North door: doors open at 2.30

No one must go without a ticket.

A Prefect in each house will mark in The

boys of his house.

 Half Holiday.

Tuesday Feb 16th 1901 exhibition

Boys attending

to day will pa

arranged th

2/6 seats

Lock up

N.B.

must

June 4th

 Notice

I have received information that

the Coronation is postponed owing

to the indisposition of the King.

Hope to have further information

later in the afternoon & shall

wish to see the School on the Terrace

at 6.45

 Notice

I do not now think it necessary

to see the School at 6.45.

It is certain that the Coronation

is postponed and it follows that

all leave is cancelled.

Boys should without delay inform

Parents or friends to whom they

were going, either by wire or post,

as it is impossible for me to do so.

June 24th /02

School House —Back, W. K. Horsfall; three-quarters, F. B. Harvey, R. S. M. White, G. C. Lucas, C. G. L. Marriott; half-backs, H. A. G. Neville, J. D. Moore; forwards, A. N. S. Jackson, J. W. Fisher, A. Mc.D. Doughty, H. E. Cullen, W. D. Cullen, L. H. Brunlees, H. W. Butler, A. C. P. Arnold.

Toppin's.—Back, W. B. Hathorn; three-quarters, H. S. Kevill-Davies, D. C. Mudie, H. Begbie, C. H. L. Cramer-Roberts; half-backs, F. I. Williams, H. Beacall; forwards, S. W. H. Welsby, C. J. Mann, H. F. Young, B. M. Peek, J. Grieve, R. W. Lush, C. Beerbohm, G. F. Marsh.

Rugby Football was introduced in 1910. School House defeated No. 6 (Toppin's) 9-3 in the first final.

The letter below is from the Headmaster to Walter Lowe, Chairman of the Games Committee.

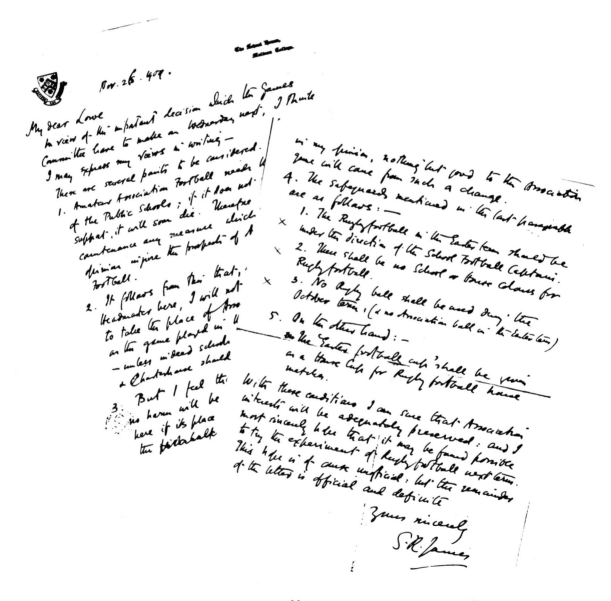

Rev. H. E. Huntington. 1889 – 1893
o.m.
(No. 4. 1889 – 1893.)

E. C. Bullock. 1889 – 1932
o.m.
(No. 9. 1898 – 1917)

A group of Housemasters around the turn of the century

L. S. Milward. 1891 – 1926.
o.m.
(No. 5. 1908 – 1915).

D. J. P. Berridge 1893 – 1927.
(No. 1. 1913 – '27)

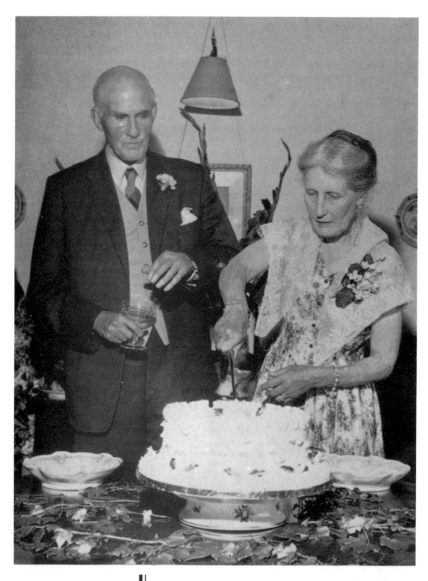

Mr and Mrs F.S. Preston on the occasion of their golden wedding.

F.S. Preston was the first lay Headmaster. He was a distinguished classical scholar who served Malvern for twenty three years. R.K. Blumenau in his centenary history concludes his Preston chapter by saying, "The School was fortunate that it had a headmaster who, though appointed before the First World War broke out, was able to guide Malvern into the directions called for by the post war world".

Mrs Preston used to ask every new boy to draw a pig blindfold. Here are a few samples.

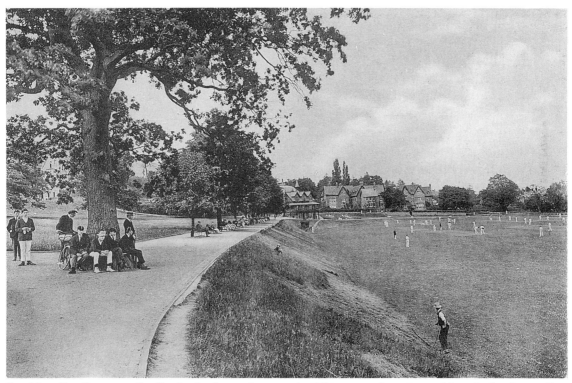

Looking South across the Senior in the early twenties.The groundsman scything the bank recalls a bygone and more leisurely age.

The Grub in break in the twenties.

This photograph taken in the Grub admirably illustrates the world of petty privilege in the twenties and thirties, accepted and taken for granted by all but a few. It is almost possible to assess the period these individual boys had been in the school. Rounded collars were obligatory for the first two years, all jacket buttons had to be fastened for a year, one hand in a trouser pocket was permitted after three terms and both after six. Note the ordinary House cap on the right and the House colour cap in the middle.

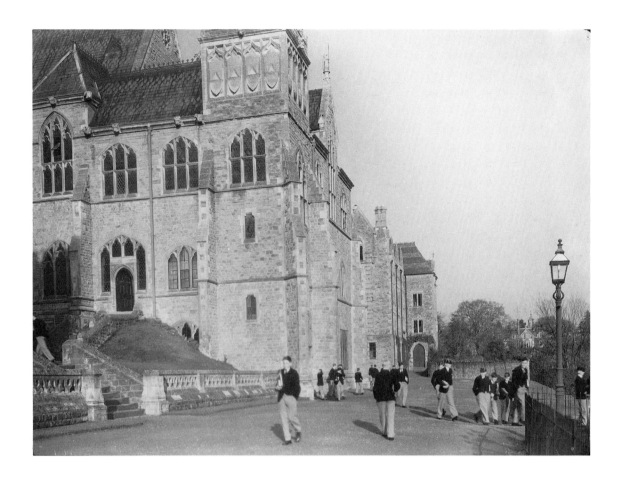

The old School House yard.

This photograph was taken shortly after the ivy was removed from the main building. The old wall still stands either side of the steps, which were only used by those who were in the sixth form or XI colours. The old stone batting crease for the School House 'Yard' on the terrace, can just be seen as can the Victorian building which predates the Lindsay Arts Centre, known to post war Malvernians as Douglas House school.

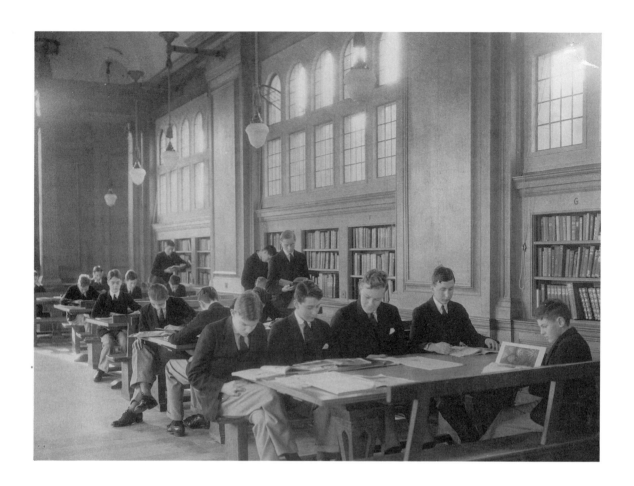

Memorial Library

The Memorial Library designed by Maurice Webb was opened in 1925 as a memorial to those who died in the first world war. For several decades this fiction library was a sanctuary where junior boys were safe from fagging. It is regrettable that the lights shown here have been removed.

SPORTS TABLE. MALVERN 1929.

	Marks	S.H.	1	2	3	4	5	6	7	8	9	D.B.	Individual Winners
OPEN													
Ledbury		6		18	8		4	30	10				D.C. Sidebottom
200yds			10							20			G.N. Crabtree
Weight							10	20					C.D.A. Pullan
Cricket Ball					16			8					J. Wardrop
School Hand.					8			16					P.B. Hilton
Low Hurdles						10				20			D.A.P. Anderson
Pole Jump								24					R.A.C. Burnett
SENIOR													
Steeplechase				12				6	24				G.C. Rush
1 Mile					12			6	24				G.C. Rush
Broad Jump						20				10			K.S. Duncan
150yds Hand										16		8	G.N. Crabtree
100yds			10							20			G.N. Crabtree
Half Mile					10				20				G.C. Rush
High Jump								10		20			D.A.P. Anderson
Quarter Mile					20					10			A.P. Hobbs
Consolation								5					J.E. Peal
House Team Race					20			10	5				No.3 {J.F. Murphy (220), R.N. Andreae (220), J. Wardrop (880)}
120 Hurdles								10		20			D.A.P. Anderson
MIDDLE													
Steeplechase								27					D.C. Folland
1 Mile					9			18					P.B. Hilton
150yds (under 16)			10			5							K.P. Bent
100yds			7					14					D.C. Folland
High Jump					14				7				G.A.V. Knyvett
Half Mile					14			7					A.C.M. Urwick
Broad Jump					14			7					G.A.V. Knyvett
Quarter Mile			7					14					D.C. Folland
Consolation										4			M.E. Parkhouse
120 Hurdles			7		14								G.A.V. Knyvett
JUNIOR													
Broad Jump						10		5					J.W. Lee
100yds				5		10							J.W. Lee
High Jump								5	10				P.C. Ashwell
Quarter Mile					5	10							J.W. Lee
Consolation								3					L.F. Romary
½-Mile Hand. (New Boys)					7			14					
Totals		37	25	30	171	45	34	254	95	146	12	0	Senior Cup No.6. Junior Cup No.6. Champion Athlete G.C. Rush.

The table shows the points awarded to each house. The column D.B. was for the Day Boy's House, which was at this time not large enough to complete as a separate entity. K.S. Duncan winner of the Broad Jump went on to win the Long Jump for Oxford and won the Silver Medal in the 1938 Empire Games.

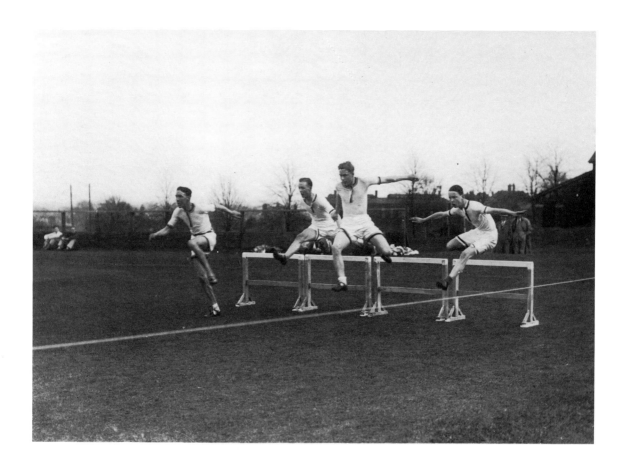

Athletics in the twenties

Track events were held on the
Senior until the sixties. Field
events took place below the Junior
nets. Note the elm trees, long since
gone, at the south end of the
junior.

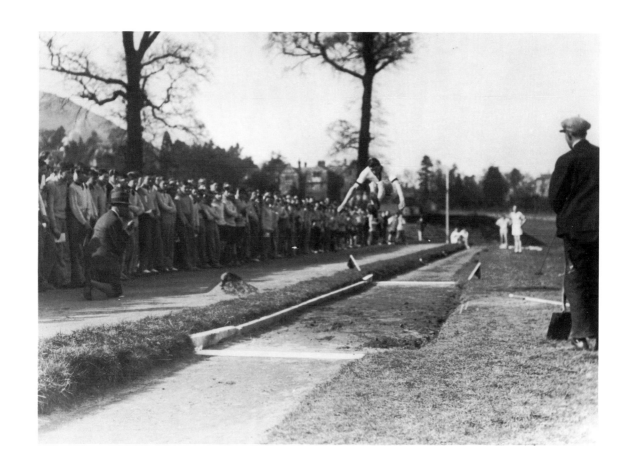

Athletics in the twenties

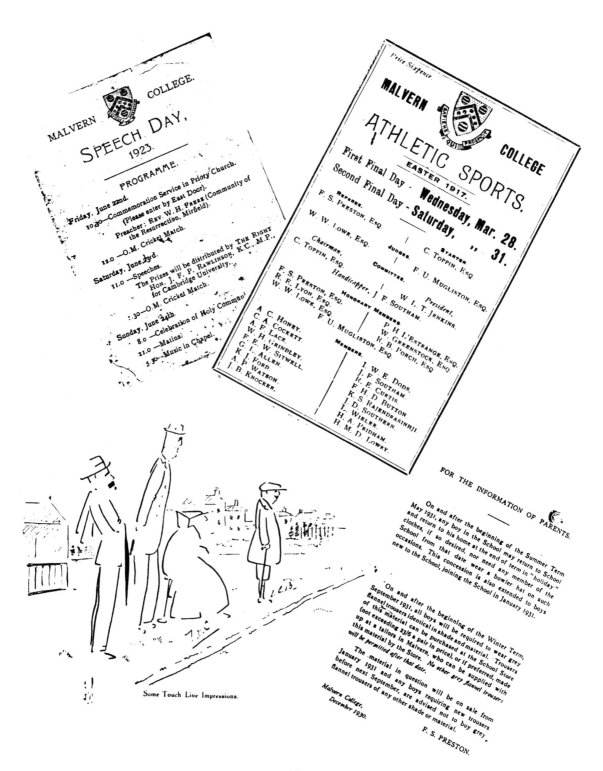

MALVERN COLLEGE.

SPEECH DAY, 1923.

PROGRAMME.

Friday, June 22nd.

10.30—Commemoration Service in Priory Church.
(Please enter by East Door).
Preacher: REV. W. H. FRERE (Community of the Resurrection, Mirfield).

12.0 —O.M. Cricket Match.

Saturday, June 23rd.

11.0 —Speeches.
The Prizes will be distributed by THE RIGHT HON. J. F. P. RAWLINSON, K.C., M.P., for Cambridge University.

.30—O.M. Cricket Match.

Sunday, June 24th.

8.0 —Celebration of Holy Communi[on]

11.0 —Matins.

5.0 —Music in Chapel.

Price Sixpence

MALVERN COLLEGE

ATHLETIC SPORTS.
EASTER 1917.

First Final Day - **Wednesday, Mar. 28.**
Second Final Day - **Saturday, " 31.**

REFEREE.
F. S. PRESTON, ESQ.

W. W. LOWE, ESQ.

C. TOPPIN, ESQ.

STARTER
JUDGES. C. TOPPIN, ESQ.

CHAIRMAN.
C. TOPPIN, ESQ.

COMMITTEE.

PRESIDENT,
F. U. MUGLISTON, ESQ.

HANDICAPPER, J. F. SOUTHAM.
W. I. T. JENKINS.

HONORARY MEMBERS.
F. S. PRESTON, ESQ.
R. E. LYON, ESQ.
W. W. LOWE, ESQ.
F. U. MUGLISTON, ESQ.

P. H. L'ESTRANGE, ESQ.
W. GREENSTOCK, ESQ.
R. B. PORCH, ESQ.

A. C. HONEY.
C. A. COCKETT.
A. H. LACE.
W. H. GRINDLEY.
F. E. W. SITWELL.
G. I. ALLEN.
K. I. FORD.
A. P. WATSON.
J. B. KNOCKER.

MEMBERS.
I. W. E. DODS.
J. F. SOUTHAM.
J. E. E. CURTIS.
F. H. D. BUTTON.
F. K. S. RAJENDRASINHJI.
J. D. SOUTHERN.
L. WIRLER.
H. A. PRIDHAM.
H. M. D. LOWRY.

FOR THE INFORMATION OF PARENTS.

On and after the beginning of the Summer Term May 1931, any boy in the School may return to School and return to his home at the end of term in "holiday" clothes, if so desired, nor need any member of the School from that date wear a bowler hat on such occasions. This concession is also extended to boys new to the School, joining the School in January 1931.

On and after the beginning of the Winter Term, September 1931, all boys will be required to wear grey flannel trousers identical in shade and material. Trousers of this material can be purchased at the School Store (not exceeding 23/6 a pair in price), or if preferred, made up at a tailors in Malvern, who can be supplied with this material by the Store. No other grey flannel trousers will be permitted after that date.

The material in question will be on sale from January 1931 and any boys requiring new trousers before next September, are advised not to buy grey flannel trousers of any other shade or material.

Malvern College,
December 1930.

F. S. PRESTON.

Some Touch Line Impressions.

C.A.F. Fiddian-Green who ran the cricket after Charles Toppin with Father Tate and A.H. Brodhurst.

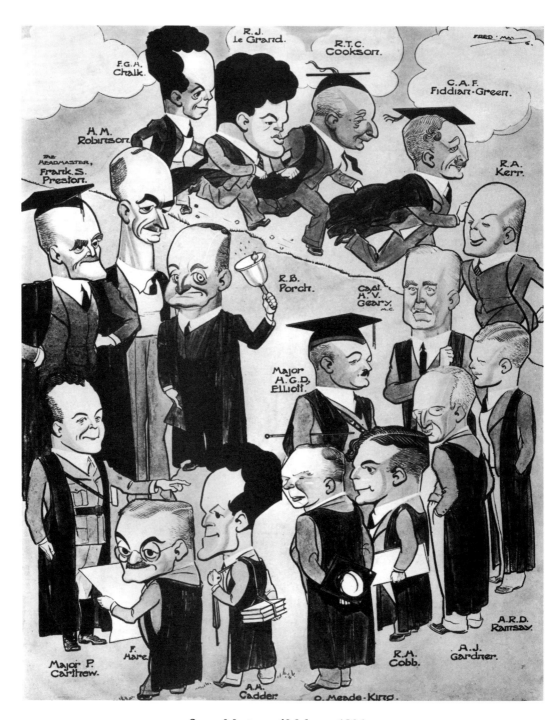

Some Masters of Malvern 1936.

The boy that forgot to raise his cap.

This cartoon appeared in 'The Beacon', for a period a popular light hearted magazine produced termly. The custom since 1922 used to be that everyone doffed their caps or hats when passing the war memorial. Since headgear is now almost a thing of the past the custom has died out.

The tragedy of U.S.a —

My dear Chester Master
You must walk rather faster,
For poor little Hubbard's
Fallen out of the cupboard
And fractured his ribs
O where is young Gibb
They'll both need a plaster
My dear Chester Master
and it's no good to call for
Dear solemn old Balfour
you were his shepherd & pastor
Mr A. Chester Master
you've lost too a morsel — in
Good looking Gosselin
O what a Disaster.
my poor Chester Master.

5 He lived upon the cricket yard
Wordsworth Hard by the Senior game
 A youth whom many tried to work
 and very few to tame.

His father's o'er the garden wall
 Half hidden from the eye.
Tim also the stir, when cricket balls
 were tow'ring in the sky.

He studied History in the Fifth.
 A modern C.G.T.
He's in an office now — and oh!
 The difference to me —

All Day has the Monastry' garden heard
 The fife, violin and bassoon,
All Night has young Kersley the dormitry stirr'd
 with averages chanted in tune,
Till the Eyes of the weary one jaded & blurr'd
 Fell full on the mobbing Moon.

E.R.ROBINS.
A promising lad was young Robins
who checked Extra v in their mobbin's
He's going far to toil
To raise Burmah oil
And left no I. went with Sotbin's.

If you met a 3/4 named Larkhouse
you'd better take care of your Carcase.
 If they cry 'you must run',
 you'd reply 'no! my son',
'There's a nasty fast fellow to mark us'.

F.S. Preston dined out every leaver and delivered his farewell speeches in verse in the style of different poets. There is no doubting his description of Tim Toppin.

MATTERS
MILITARY

═══════════

Matters Military

Most Malvernians have a love hate memory of the corps, nonetheless inspections, camps and field days have been for over a hundred years important features of the school calendar. If the Head of House was a corps fiend the Squad Drill competition meant endless button cleaning for fags, and hours of practice for the squad. Few can forget in the days of puttees, the rush after lunch on Wednesdays to find kit in the changing room which was fit to wear.

The corps was started by Henry Foster Housemaster of No. 5 at the express wish of the boys in 1883. It was for thirty one years an Artillery Cadet Corps and for the last twenty of these it was the only artillery cadet unit in the country.

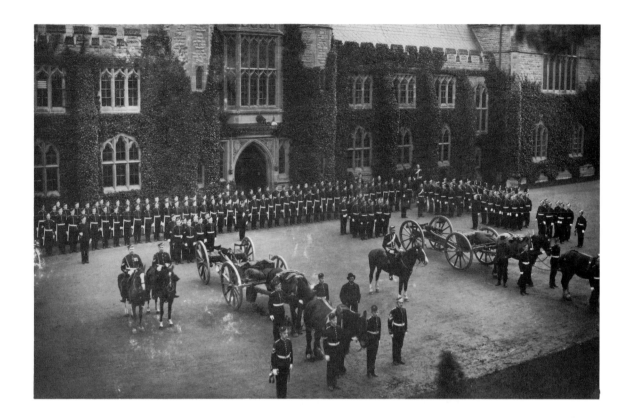

1891. The parade before marching off to a Field Day on Castle Morton Common with four other schools. The Nine Pounder muzzle loading guns dating from the Crimean war were housed in the Gun Shed (now the Caving Store) near the Chapel. The horses which pulled the guns were loaned by Mr Jones, in the bowler hat, a local coal merchant. On one famous occasion when a number of cadet forces paraded in Marlborough High Street, with Malvern as the only artillery unit taking the 'right of the line', it began to rain heavily; Mr Jones insisted that his horses should be covered. Much to Malvern's chagrin the covers bore in large white letters JONES BROS, COAL MERCHANT.

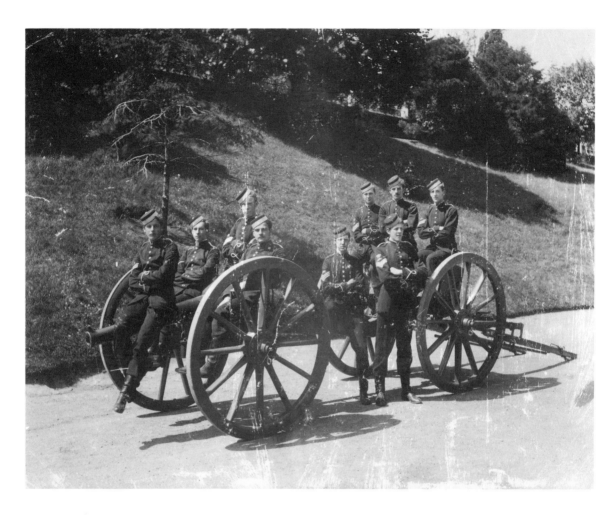

Signals

Nature	By whom given	Meaning
Right hand raised as high as the shoulder	No. 4	My gun is laid
Motion with either hand in the required direction, arm well back.	No. 4*	Trail right or left.
Drops his hands	No. 4*	Halt (traversing).
Points to vent with his right hand	No. 1	Make ready.

* Only when great accuracy of line is required the laying for direction is done by No. 4.

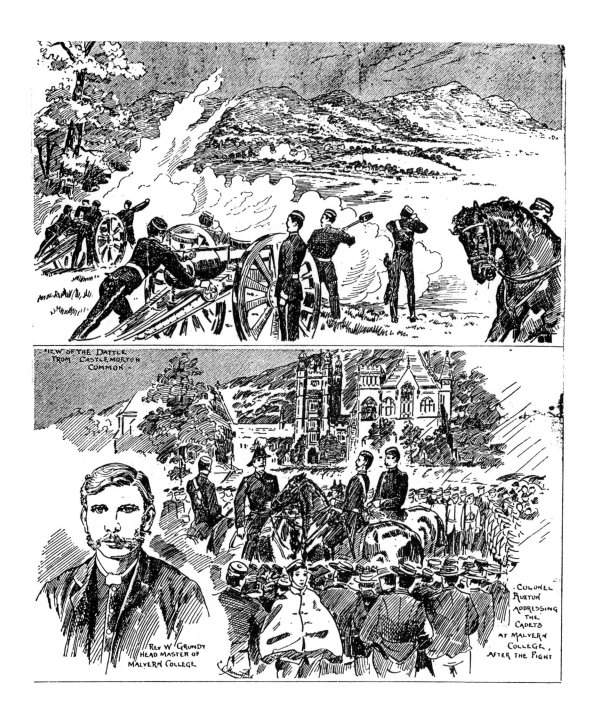

Field day 17th October 1891

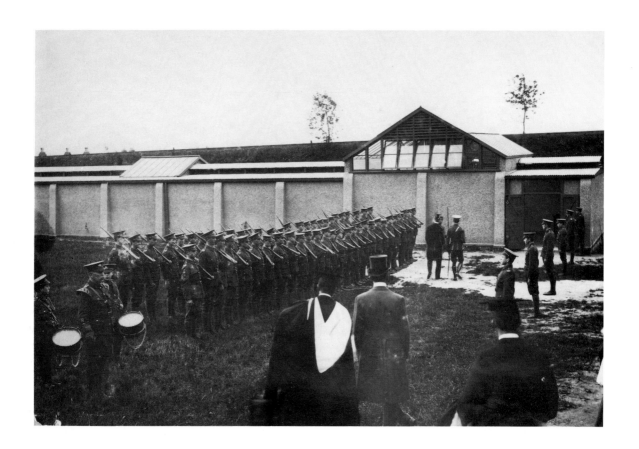

S.R. James assured parents that
there was no compulsion to join
the corps, "Compulsion is foreign
to the very nature of
volunteering". The rifle range,
little changed to the present day
was opened by General Lyttleton
in 1907.

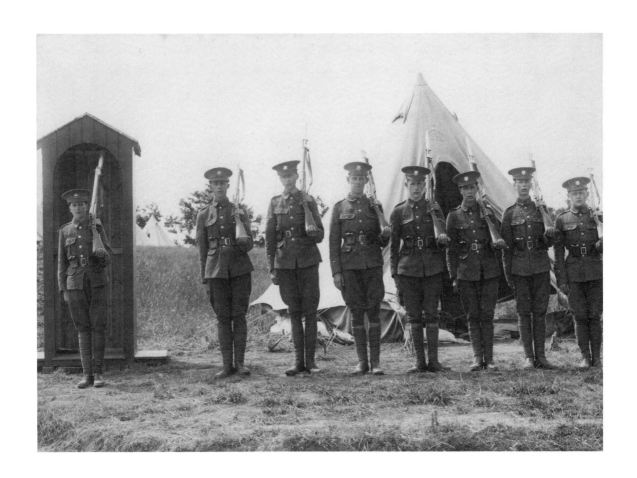

In both world wars the corps was given a greater sense of purpose, two parades a week were the norm. In this picture taken at camp in Swanage in 1915 it is worth noting that the cap badge represented the Malvern coat of arms.

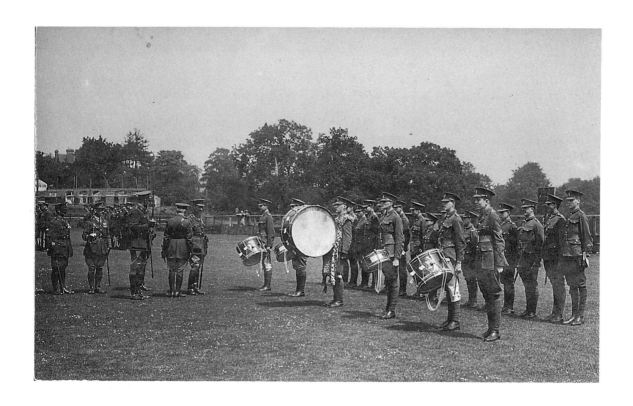

The band at the Inspection of 1927. In the left background can be seen the Grub under construction.

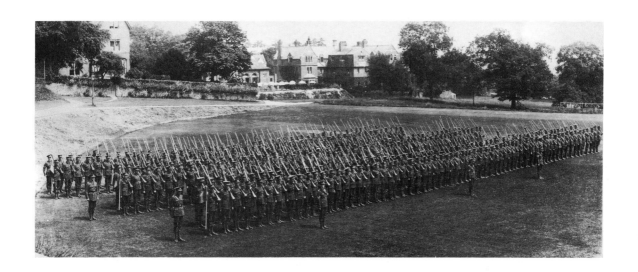

Corps inspection in 1932. Note the umbrellas on the Grub Lawn, and on the extreme left the corner of No. 2 tennis court.

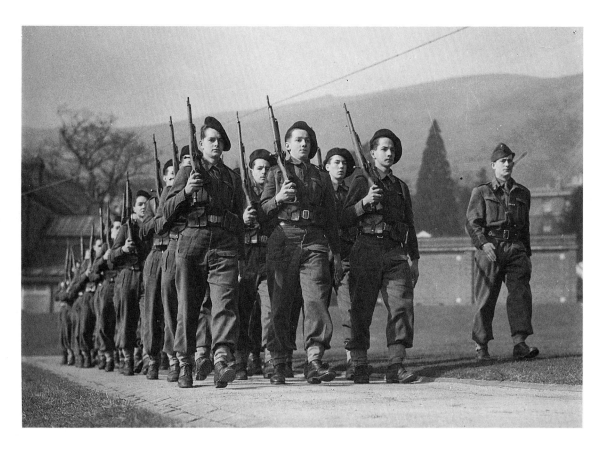

The Free French took over No. 5 in 1940 for their officer training school. A platoon is shown marching towards the House.

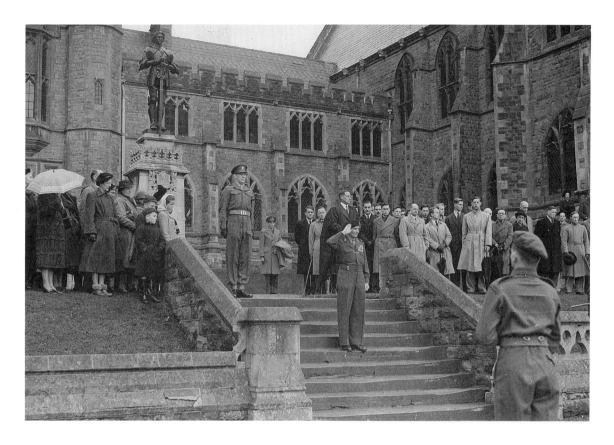

The visit of Field Marshal
Montgomery December 1950

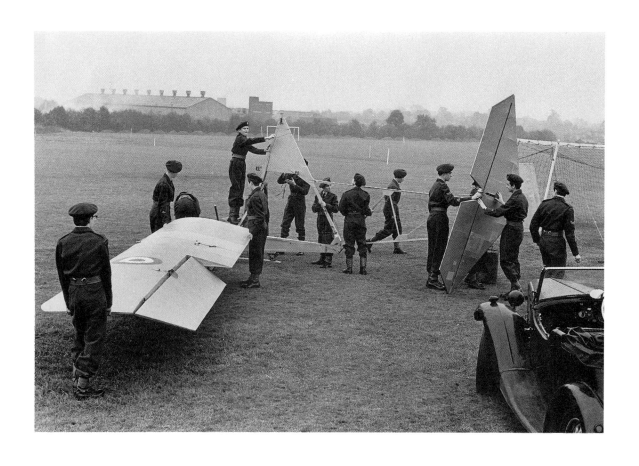

The glider was a feature of life in
the RAF Section through the
fifties and sixties. The
complicated process of assembly
is shown taking place on a
summer afternoon in 1964.

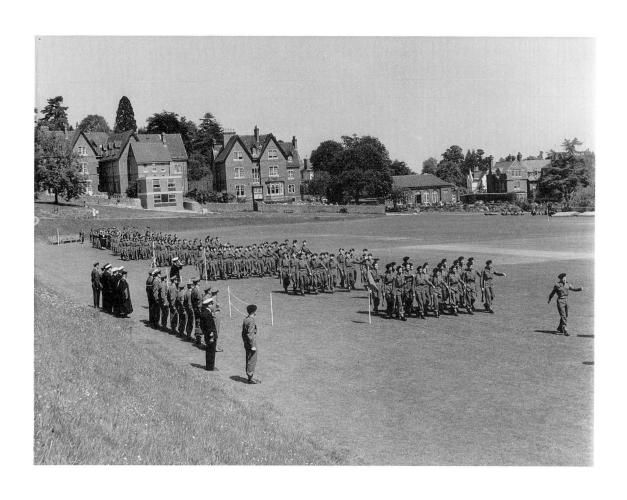

The 1966 ceremonial inspection, one of the last to be held on the Senior, was carried out by Rear Admiral A.M. Lewis.

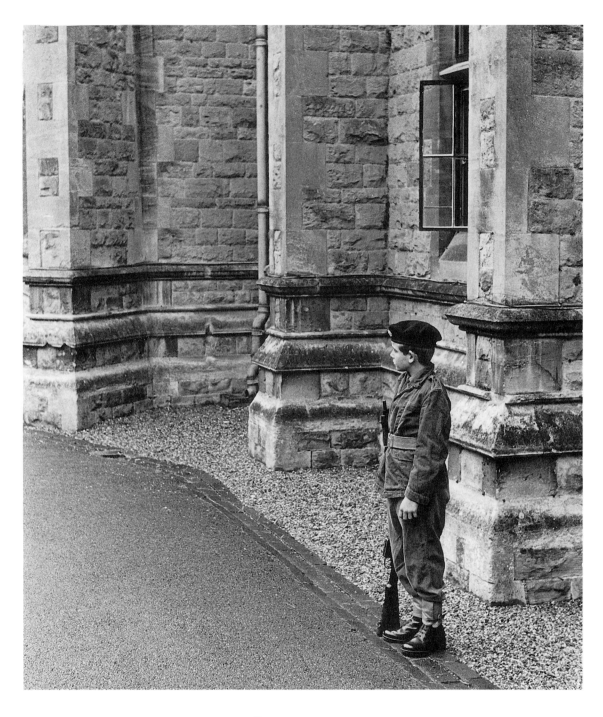

Let no one pass

TWO
EXILES

————————

H.C.A. Gaunt had hardly settled into his Headmastership when he was faced with the possibility of the College buildings being requisitioned in the event of war. That he was not permitted to share this information merely added to his problems. When the time came the school was happily moved to Blenheim and returned a year later, but on the understanding that they might once again have to leave, and so it transpired.

In 1942 they all packed their bags for Harrow, and did not return for over four years. When Malvern did return the numbers had dropped to 402. In the next seven years they were remarkably raised to 574. Few Headmasters can have faced such problems.

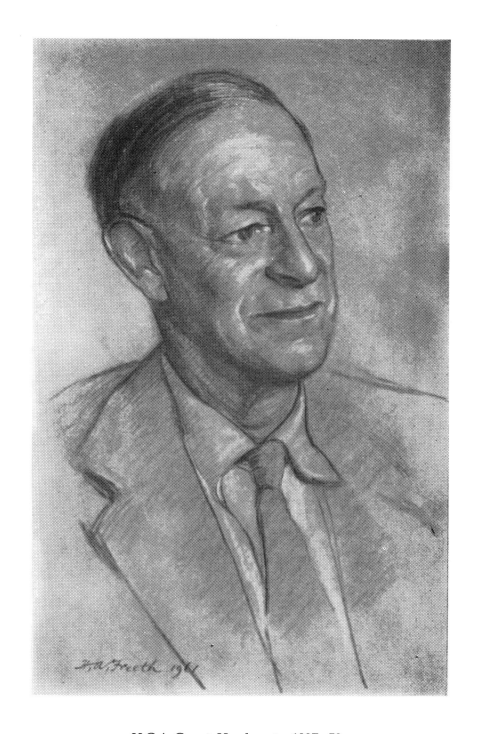

H.C.A. Gaunt. Headmaster 1937 - 53

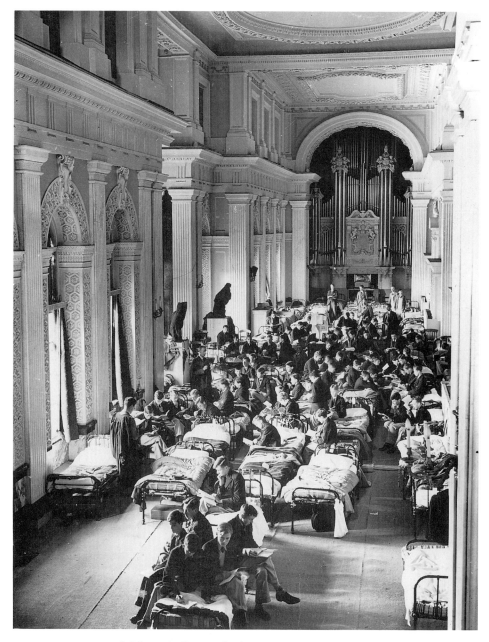

Malvern's first exile during the 1939-45 war.
The Long Library at Blenheim served as a dormitory for School House and most of No. 1. School House also used it for House Prayers with the opportunity to use the organ being too good to miss. The parquet floors were protected with coconut matting, the walls with Essex boarding and those statues which were immovable were cloaked in blankets.

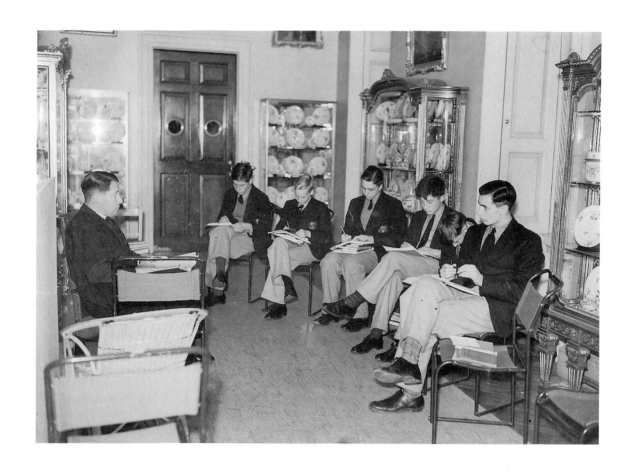

'100 Latin'
Rev W.O. Cosgrove, House-
master of No. 3 was one of a
select few in the Common Room
who saw the School through the
war. He is seen here teaching latin
to his '100' set.

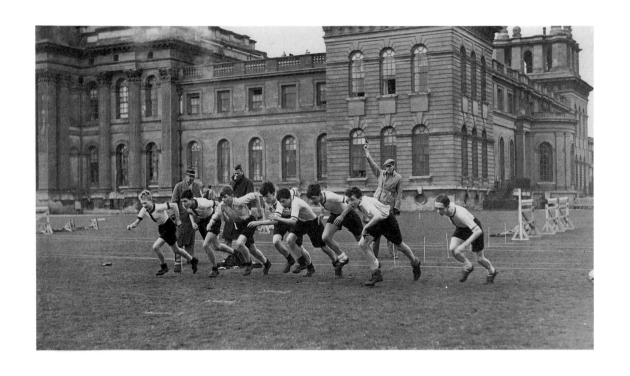

The 440 Yards
Malcolm Staniforth starts the 440 yards. The lawns on the south front of the palace lent themselves well for cricket, football and athletics. The humbler levels of sport took place beyond the ha-ha. Even Jock, Malvern's faithful groundsman, struggled to make wickets out in the park.

Malvern College, Salters.
7th November 1943

Dear Mum and Dad,

I hope you are getting on well, we have had a very exciting week-end.

On Friday an old Harrovian, who is a very important character in Britain, came to Harrow and listened to some old Harrow songs at a concert in the Speech Room, he then got up and made a speech. Not all Malvernians got into the Speech Room because all the Harrovians, masters, friends and parents got in and then the Malvernians had a chance, but as it was in form order I had little hope, as it was I managed to be the last person in, wasn't it lucky!

Yesterday we played Bradfield 1st XI and we won both 1st XI 2-0, 2nd XI 6-2.

This afternoon we are going to see a film, which happens to be 'Random Harvest'. It is a great pity that you are not coming to see it.

With love from
Mick.

P.S. The person, who is so important, happens to be Winston Churchill.

* * * * *

Extract from a speech of the Prime Minister, Winston Chu...

'You have visitors here now in the shape of a sis... is a very fine affair – to meet the needs of war, t... that serve side by side in some famous briga... was very sorry that I myself had to be res... of our establishments which made i... notice. But everybody at the Scho... ...rry away with them a mem... ...and, no doubt, ...

Malvern College, 4th May 1942

...e inconvenience caused by the postponement of the ...y short notice, and we are writing to explain why this ... with which we have had to deal.

...the College Buildings were suddenly requisi... ...essential to the national war effort. At once ...orities to revoke the order and powerful ...became clear that the authorities had ...ealing to the College by this second ...oid it. But no alternative could be ...to disclose the reasons for this. ...disclosed were unanimously.

...k this ...as been to ensure that
...nts ...has been to preserve
...was very carefully
...nt the breaking
...he great
...great

Dear Parent or Guardian,

I am sending you in this letter a short account of our life at Blenheim so far, and I intend to send you similar letters from time to time. We have been immensely encouraged by the support so many of you have shown us, but I realise, as a parent myself, the natural anxiety as well as the interest you will feel in the new chapter in our history.

By Thursday evening las... learned the new routine. The... running smoothly. The... have been extraord... though we were... expectations...

...School back arrived back. On Friday and Saturday we ...we started a full timetable which appears to be ...the new conditions has been magnified. They ...pick up the hundred new regulations, and ...o a crisis, the result has far exceeded our ...praised especially the good manners and ...'s new ...hool.

H.C.A. Gaunt.
School House,
Malvern College.

8th September 1939

Malvern College
at/ Blenheim Palace,
Woodstock, Oxon.
19th October 1939

Dear Sir or Madam,

I regret to have to tell you that His Majesty's Government have informed me that the Houses and buildings of Malvern College will be required almost immediately for war purposes. Fortunately the Government gave me warning of this probability some time ago, and we have been able to make our plans in good time; I may add that hitherto I have been bound by the Government to the strictest secrecy.

The College will re-assemble at Blenheim Palace, Woodstock, the seat of His Grace the Duke of Marlborough. The Palace is large enough to house the entire School and many of the Staff, and the facilities contained in the magnificent buildings and grounds will make it possible for all normal School activities to be continued. The Estate contains its own farm and vegetable gardens, which will supply the School. The State rooms are being converted into dormitories and classrooms, and the School will feed together in the Great Hall. At the same time the House units will be kept, and all boys will be under the care and supervision of their present House Masters. Woodstock itself is in the heart of the country in a reception area, while the Palace itself contains admirable shelter against Air Raids.

In due course, and in good time, I shall be sending you further particulars and instructions regarding the beginning of next term. I hope we shall be able to start on September 28th as arranged. Meanwhile, in view of the heavy task which confronts us at Malvern in moving to Blenheim, I should be grateful if you would avoid for the time being any correspondence which requires an answer, unless it is very urgent.

The continuance of Education is a matter of great national importance, both for the prosecution of the war and for the tasks of reconstruction which will follow when peace returns again. I am entirely confident that with the willing co-operation of all concernted the College in its new surroundings will continue to contribute as greatly towards Public School Education as it has in the past.

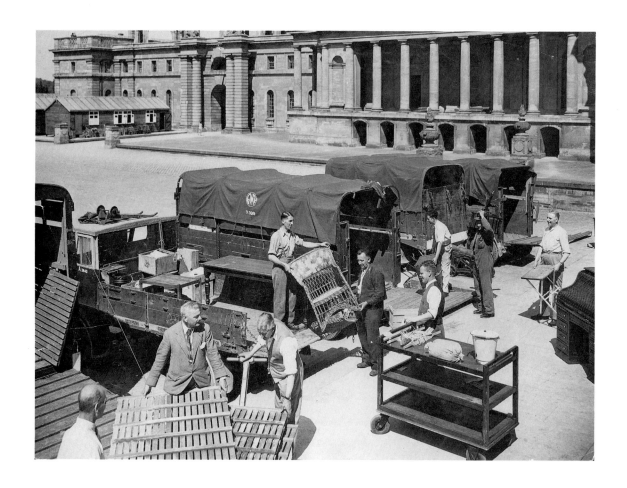

Packing to go home. Note that F. Hare and F.W. Roberts are in the left foreground. Two of the huts which served as classrooms can be seen on the left.

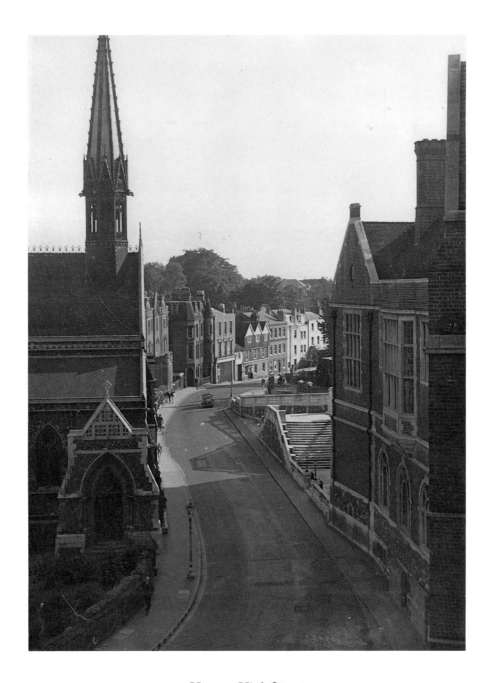

Harrow High Street

The year at Blenheim had been vividly recorded with photographs, the four years at Harrow were scarcely recorded at all. Anyone who knows Harrow High Street today with its bumper to bumper traffic would hardly believe this view.

Malvern Notice Board
This picture is evocative of the "make do" spirit of an independent Malvern College at Harrow.

Malvern College,
5, High Street,
Harrow-on-the-Hill.

Flying Bombs.

I am sure parents will wish to know what the situation at Harrow is, and what precautions are being taken and arrangements made.

Though one or two bombs have fallen about a mile from the School and a few have passed over, no damage has occurred on the Hill. All boys are sleeping in shelters or else in the safest places in their Houses; dangerous windows are being protected; a watch is being kept night and day for the approach of bombs, and a warning is sounded in class rooms and Boarding Houses if they come close; boys are also trained in taking rapid cover within a few seconds on an emergency alarm. The occasions for this have been very infrequent.

It is, I am sure, our duty to continue the running of the School as normally as possible, and so far routine has been very little interrupted. There is no doubt that boys can pursue their usual studies and games without undue distraction or risk, and parents may be assured that the general efficiency of the School is little, if at all, impaired.

At the same time it cannot be said that no risk is attached, and if any parents wish to have their boys home temporarily, they are quite at liberty to do so. This applies more particularly to younger boys and to those who have no important examinations or responsibilities in the School. I hope, however, that all older boys will remain to take their part in the normal life of the School. I should be grateful if parents would address any communications to their boy's Housemaster.

I should like to thank parents for their understanding and forbearance so far. The trust and confidence which they have placed in us has been very greatly valued, and has made a marked contribution to the excellent spirit of the School, and has eased the task of those who are responsible for the welfare of the boys.

H.C.A. Gaunt.

29th June, 1944.

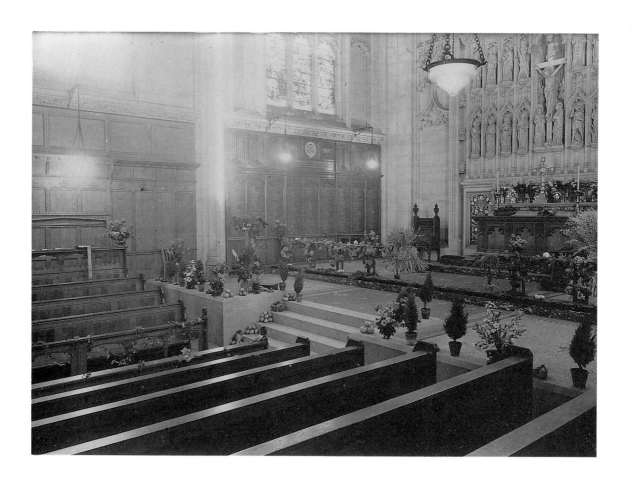

Meanwhile back at Malvern
Harvest Festival in 1943
in the time of TRE

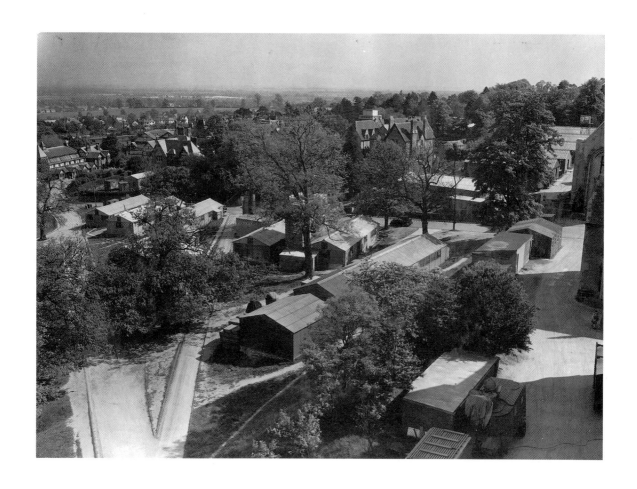

Huts in the grounds

Huts were built all round the grounds.
Fortunately A.P. Rowe the Director of TRE
had a love of cricket and he made sure
that the Senior and Junior were left clear.

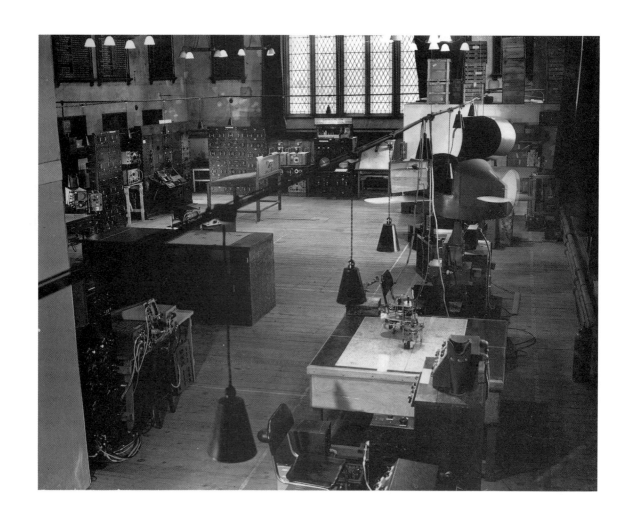

Big School under T.R.E.
Laboratories, drawing offices and
research centres were distributed
around the school buildings and
in purpose built huts. Much of
the Second War radar was
developed at Malvern. Not totally
idly has the claim been made;
"the Second World War was won
on the playing fields of Malvern."

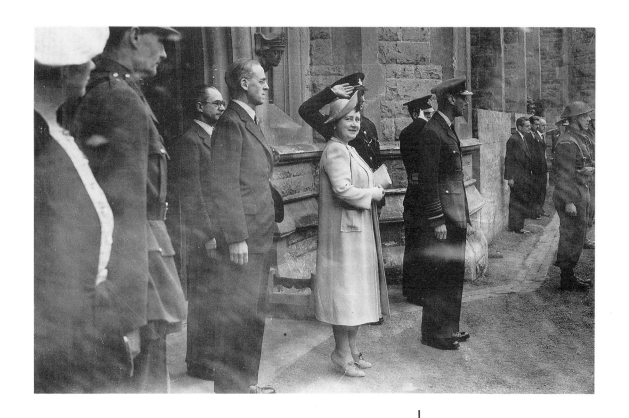

The visit of H.M. King George VI and H.M. Queen to TRE in 1944. Sir Stafford Cripps is on the right of the Queen and A.P. Rowe Director of TRE behind her. A.P. Rowe later became Vice Chancellor of Adelaide University. On his retirement, he came back to teach at The College.

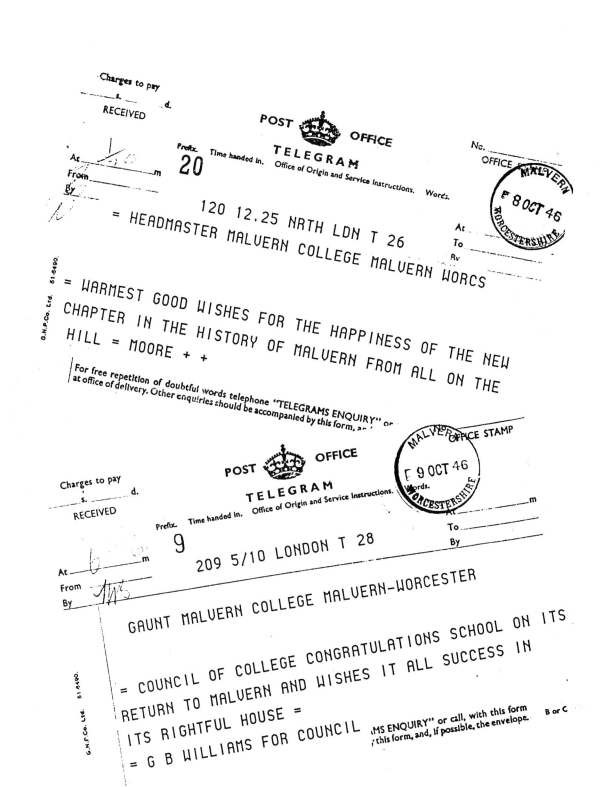

POST OFFICE TELEGRAM

Charges to pay
s. d.
RECEIVED

At
From
By

Prefix 20 Time handed in. Office of Origin and Service Instructions. Words.

No.
OFFICE STAMP
MALVERN
F 8 OCT 46
WORCESTERSHIRE

At
To
By

120 12.25 NRTH LDN T 26

= HEADMASTER MALVERN COLLEGE MALVERN WORCS

= WARMEST GOOD WISHES FOR THE HAPPINESS OF THE NEW
CHAPTER IN THE HISTORY OF MALVERN FROM ALL ON THE
HILL = MOORE + +

For free repetition of doubtful words telephone "TELEGRAMS ENQUIRY" or
at office of delivery. Other enquiries should be accompanied by this form, an

POST OFFICE TELEGRAM

Charges to pay
s. d.
RECEIVED

Prefix 9 Time handed in. Office of Origin and Service Instructions.

OFFICE STAMP
MALVERN
F 9 OCT 46
WORCESTERSHIRE

Words.
To
By
m

At
From
By

209 5/10 LONDON T 28

GAUNT MALVERN COLLEGE MALVERN-WORCESTER

= COUNCIL OF COLLEGE CONGRATULATIONS SCHOOL ON ITS
RETURN TO MALVERN AND WISHES IT ALL SUCCESS IN
ITS RIGHTFUL HOUSE =
= G B WILLIAMS FOR COUNCIL

...MS ENQUIRY" or call, with this form
this form, and, if possible, the envelope. B or C

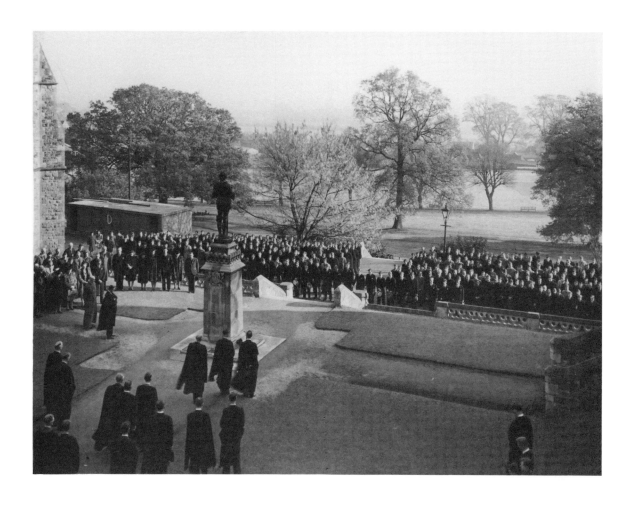

The first Remembrance Day back at Malvern 1946. This ceremony has been conducted in almost exactly the same form since 1922 when St George was raised on his plinth.

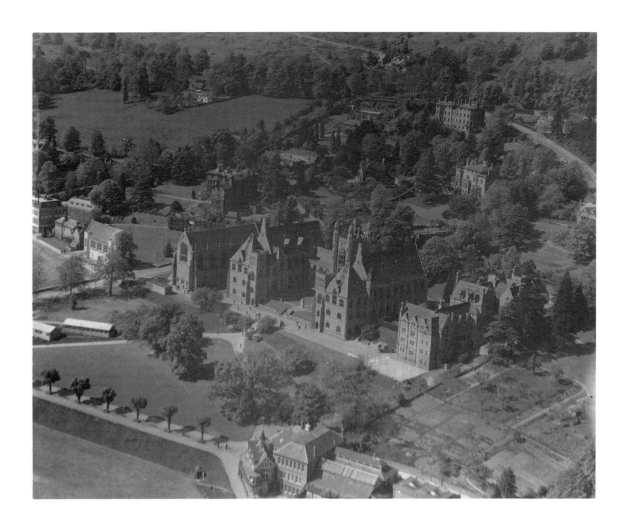

1947. Some huts can still be seen
in the grounds and the war time
allotments below No. 9 were
apparently in use. School House
yard has just been constructed.

THE
LINDSAY
YEARS

D.D. Lindsay Headmaster 1953-1971

Donald Lindsay leaves chapel with Dick Thornley, Roger Gillard, Jim Bolam and George White.

George Sayer with his VI A Set

George Sayer was responsible for the production of Age Frater (A portrait of the school.), at the time of the centenary twenty five years ago. This excellent book is now something of a rarity. This is one of the photographs from it.

Leonard Blake and choir
practice.

Leonard Blake died in 1989. He
was always much admired and
remembered with affection,
tinged with awe, for his never
ending pursuit of excellence.

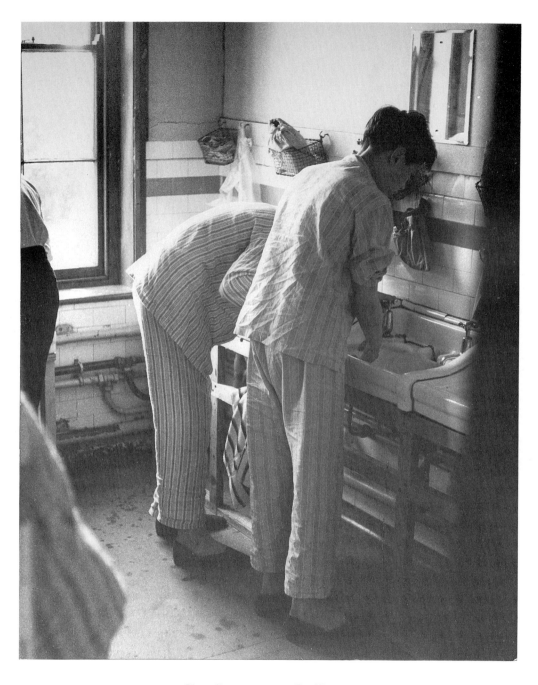

Cleanliness next to Godliness.
Michael Ward's splendid photograph of early morning conjures up more than almost any other,
the feeling of boarding school life.

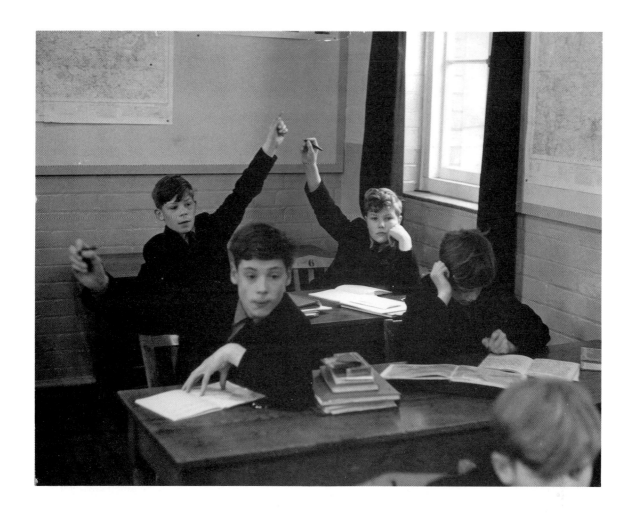

Please, Sir!

======

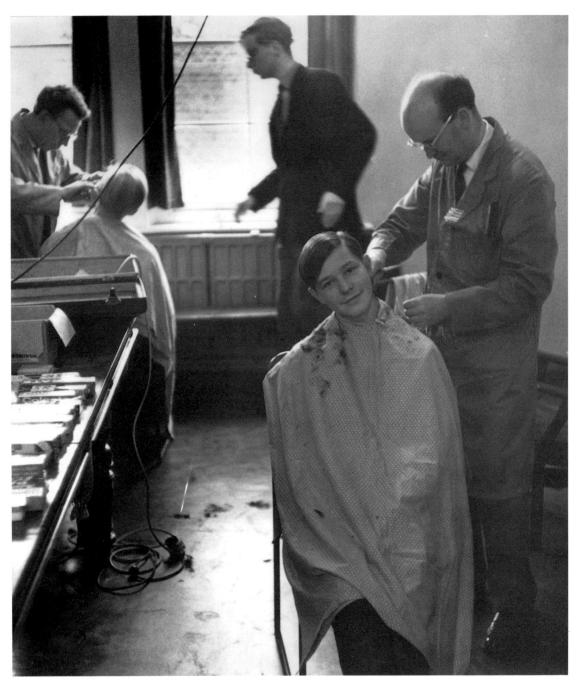

Messrs Burley and Hood at work in No.5. The Burley family have been the school barbers for three generations.

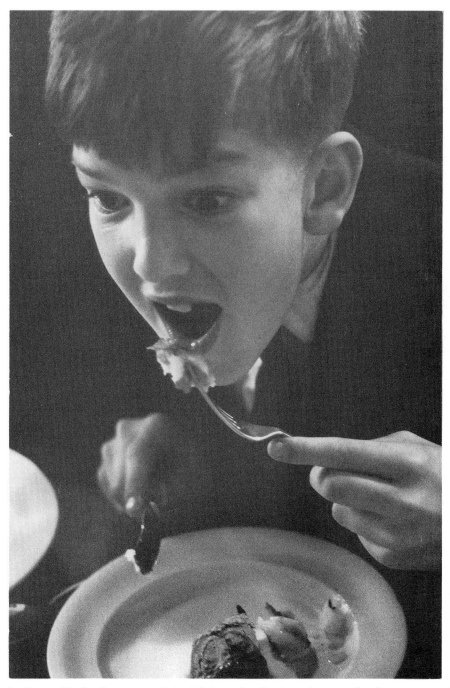

In communication with the Secretary of the Malvernian Society three topics figure more than others for nostalgic comment. The Chapel, the Corps and House food. There seems to be no complaint here.

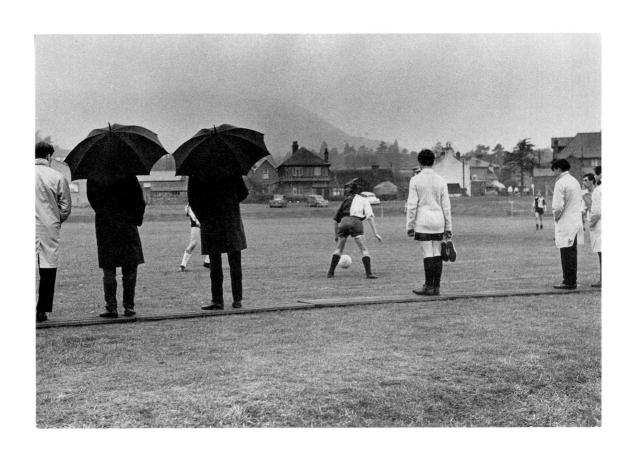

The Football XI in action 1964

Sadly it was not many years after this that the "Green and white shirts, quartered, with a Maltese cross" disappeared. Perhaps they will be recalled.

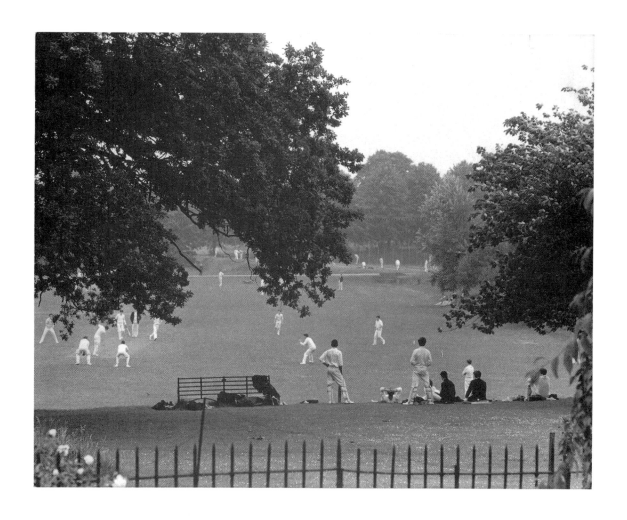

The Junior in May, from No. 5 Garden

This splendid photograph by Michael Ward captures
the essence of a summer afternoon.

MALVERN COLLEGE CENTENARY CELEBRATIONS

Mr and Mrs G H Chesterton

The Chairman & Members of the College Council
request the pleasure of your company at the
Opening Ceremony. Speaker:
The Rt. Hon. Harold Macmillan, PC, DCL
on Thursday 22 July 1965 at 3 pm and
afterwards at a Garden Party

Please see reverse for details
RSVP Centenary Secretary Malvern College

College 2358
nary Celebrations

VISIT OF HER MAJESTY
QUEEN ELIZABETH
THE QUEEN MOTHER

2021

AY 24 JULY 1965

the College Grounds

Malvern College
Centenary Celebrations

GARDEN PA
SATURDAY 24 JULY 1

Malvern College
Centenary Celebrations

A

OPENING CEREMONY

THURSDAY 22 JULY 1965

3 pm in the Marquee
Admission to the Marquee from 2.15 pm
Please be seated by 2.45 pm
Block A Platform Entrance

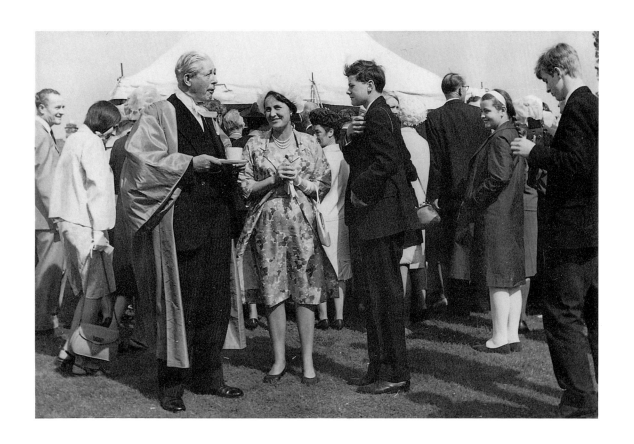

The Rt Hon. Harold MacMillan who opened the Centenary Celebrations, seen here talking to Mrs Foxall.

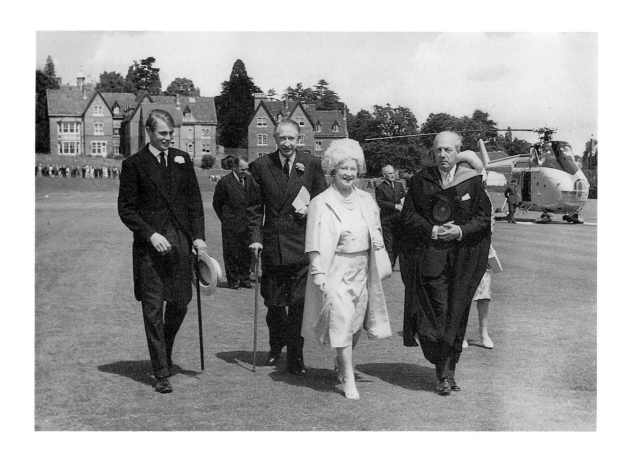

The visit of Her Majesty Queen Elizabeth the Queen Mother, she is with A.D. Roberts 8, 60-65, Sir John Wheeler. Bennett, Chairman of the College Council, and the Headmaster.

RACKETS 1966

J.H. Manners S.J. Broughton

P.F.C. Begg R. Hughes P. d'A. Mander

Winners of the Public Schools Championship

Rackets

Only a year after this photograph was taken Patrick Mander was killed in a motor accident. A racket is annually awarded in his memory.

Racket pairs who have won the Public Schools Cup.

1892 H.K. Foster & W.L. Foster	1937 P.D. Manners & N.W. Beeson
1900 B.S. Foster & W.H.B. Evans	1966 P.F.C. Begg & P. d'A. Mander
1908 M.K. Foster & N.J.A. Foster	1974 M.W. Nicholls & P.C. Nicholls
1920 C.G.W. Robson & J.A. Deed	1975 P.C. Nicholls & M.A. Tang
1936 P.D. Manners & N.W. Beeson	1977 P.J. Rosser & A.J.B. McDonald

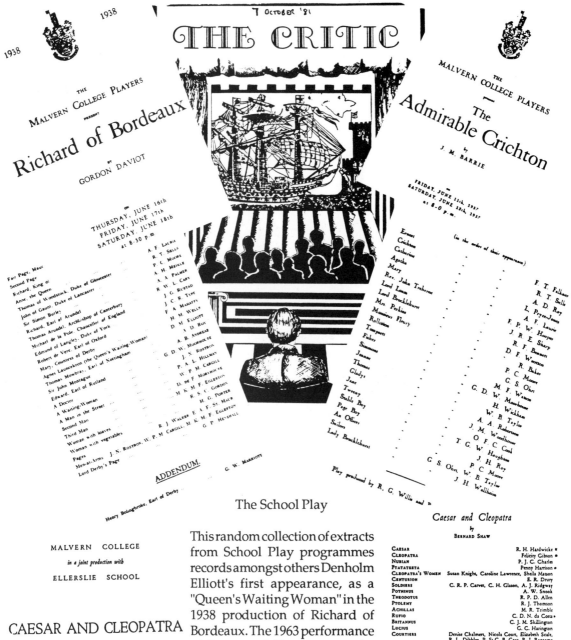

The School Play

This random collection of extracts from School Play programmes records amongst others Denholm Elliott's first appearance, as a "Queen's Waiting Woman" in the 1938 production of Richard of Bordeaux. The 1963 performance of Caesar and Cleopatra was the first joint production with Ellerslie. 1966 saw the move to The Festival Theatre.

BUILDING FOR THE FUTURE

M.J.W. Rogers
Headmaster 1971-82

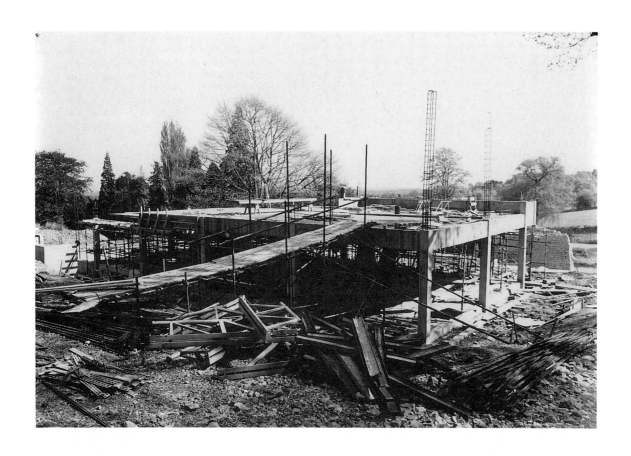

The Seventies was a period of further advance and much building with the Lindsay Art Centre and the Sports Hall taking pride of place.

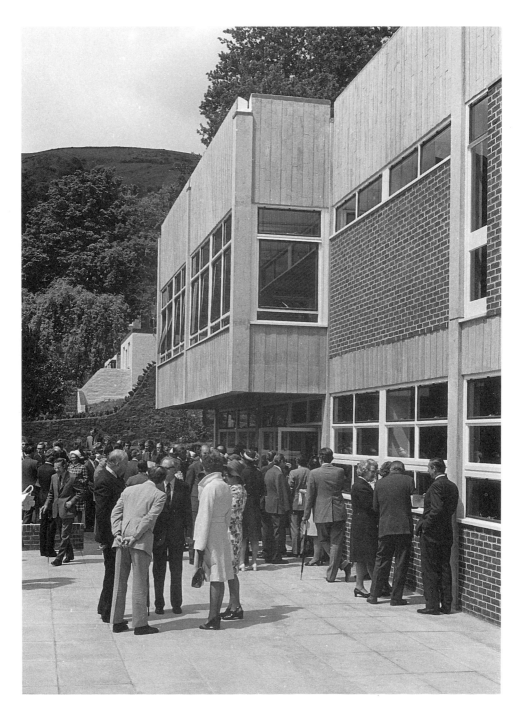

The Lindsay Arts Centre was opened by Osbert Lancaster on June 7th 1974.

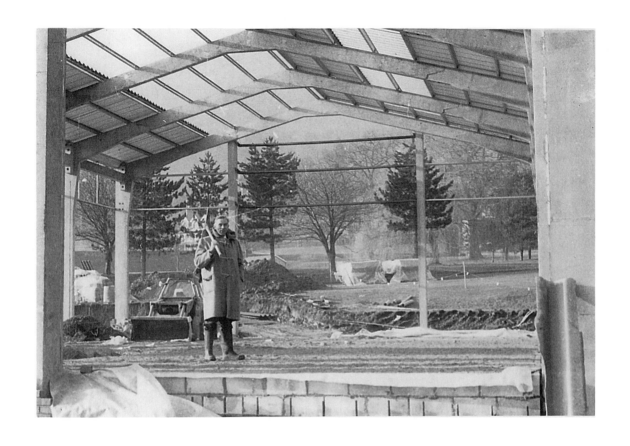

The Sports Hall under construction

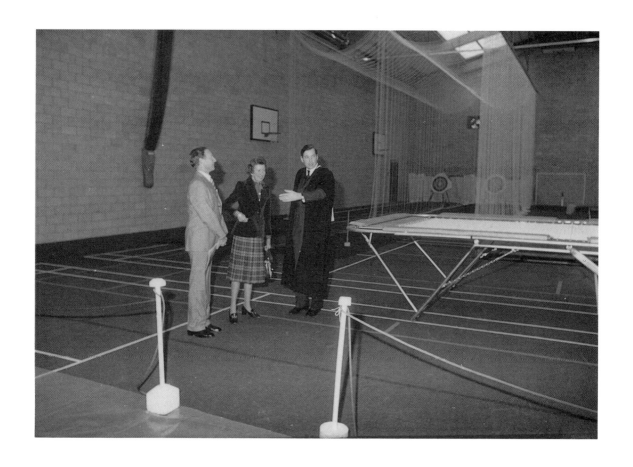

Opening of Sports Hall by Lady
Holland-Martin with Martin
Rogers on her left and Sir Stephen
Brown on her right.

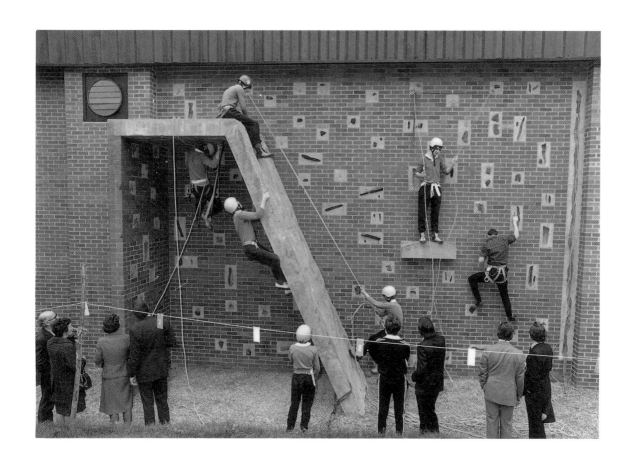

Climbing wall on the Sports Hall.

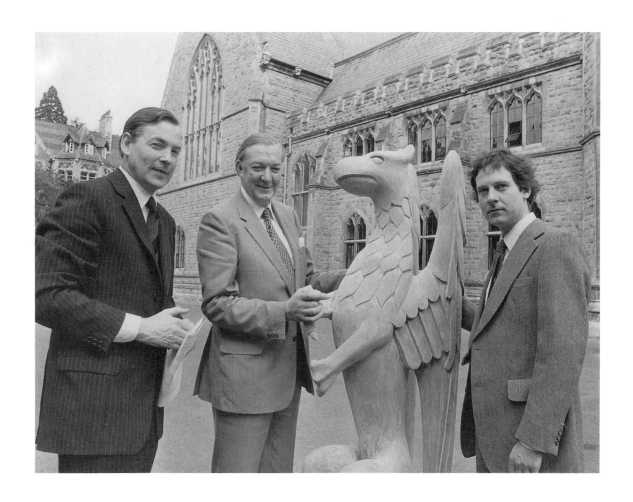

The New Gryphons. This fibre glass Gryphon, presented by Cyril Lace was one of four designed by the sculptor Ian Wilton on the right, to replace those removed. Shaking hands with the beast is the Rt Hon. Mark Carlisle Minister of Education with Martin Rogers on his right.

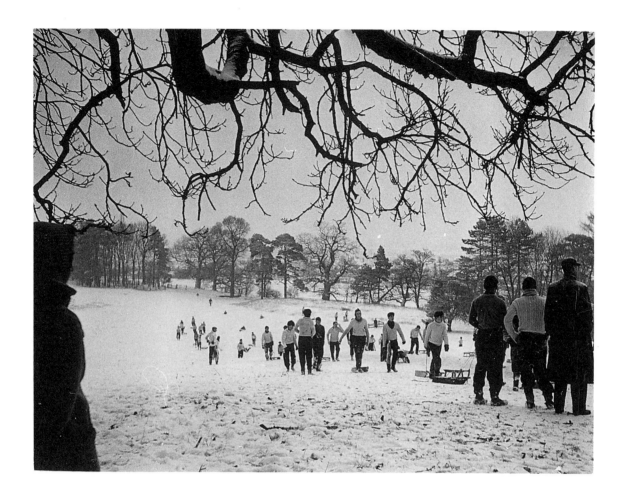

Toboganning in the Firs

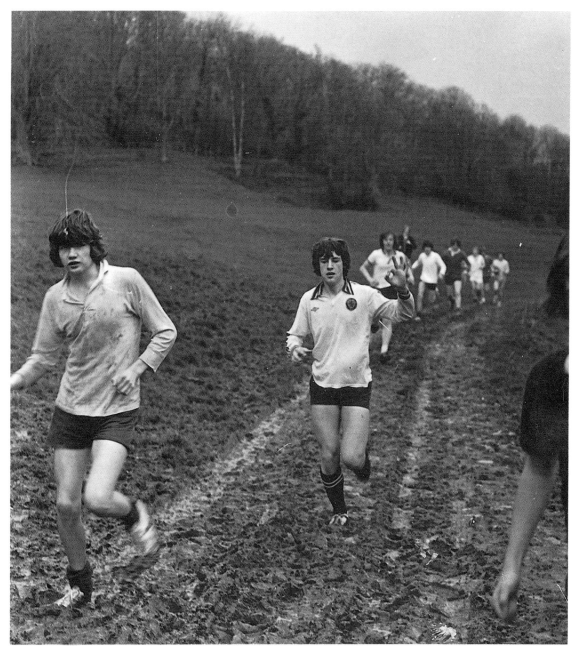

The Ledbury Run 1976

In 1986 the 100th 'Ledder' was run, this total included the Blenheim and Harrow years. 1991 will be the 100th run from Ledbury. In 1976 the race was won by J.A.H. Potter who had been second the year before.

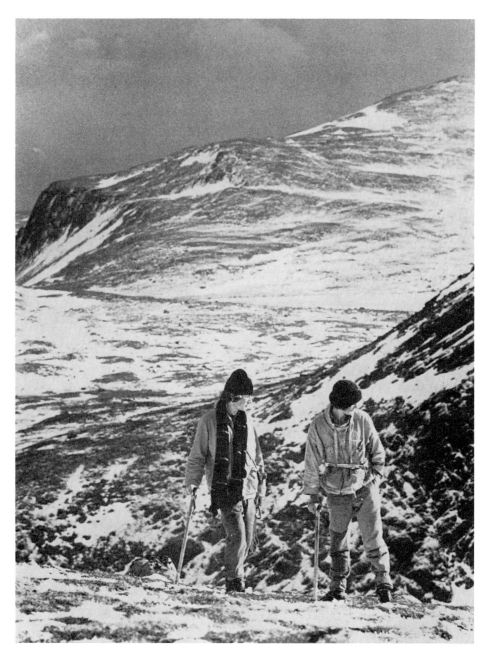

Cairngorm Expedition 1973
Since 1957 groups of Malvernians, past and present, have taken part in expeditions during the Easter holidays in the Cairngorms to practise snow and ice climbing and Winter camping. Many have then gone on to more formidable climbing expeditions in other parts of the world.

The Common Room 1977

	Came	Subject
HEADMASTER:		
M. J. W. ROGERS, Trinity Hall, Cambridge	1971[1]	Chemistry
Headmaster's House, College Road.		
Tel. 4472.		
ASSISTANT MASTERS:		
G. H. Chesterton (O.M.), Brasenose, Oxford	1950[1]	Geography
(Second Master)		
Orchard House, College Grove. *Tel.* 5745.		
J. L. Lewis (O.M.), Pembroke, Cambridge	1946[2]	Physics
Pump Cottage, Colwall Green. *Tel.* 85 40707.		
(Office: *Tel.* 61413).		
R. H. Farrar, St. John's, Cambridge	1949[2]	Maths.
6 Firs Close. *Tel.* 2527.		
R. A. Stobbs, New College, Oxford	1949[2]	Modern
Firs House. *Tel.* 2910.		Languages
N. Rosser, J.P., St. John's, Cambridge	1951[1]	Geography
1 The College. *Tel.* 61121.		Maths.
G. A. Shaw, Loughborough College	1951[2]	Handicrafts
Crendon, 23 Geraldine Road. *Tel.* 3318.		Maths.
R. P. Hooley, Christ's, Cambridge	1953[2]	Classics
110 Graham Road. *Tel.* 62706.		
D. F. Saunders, Exeter, Oxford	1953[2]	Geography
7 The College. *Tel.* 61127.		
A. I. Leng, D.S.C., Magdalene, Cambridge	1954[2]	Modern
Firs Cottage. *Tel.* 3710.		Languages
J. M. McNevin, Pembroke, Cambridge	1955[2]	Chemistry
2 The College. *Tel.* 61122.		
K. M. Grayson, St. Edmund Hall, Oxford	1955[2]	Physics
6 The College. *Tel.* 61126.		
R. K. Blumenau, Wadham, Oxford	1957[2]	History
11 The Lees. *Tel.* 4572.		
G. R. Scott, Jesus, Cambridge	1957[2]	Maths
4 The College. *Tel.* 61124.		
M. G. Harvey, St. John's, Oxford	1959[2]	Modern
3 The College. *Tel.* 61123.		Languages
A. C. S. Carter, Worcester, Oxford	1960[2]	English
Flat 1, Ashfield, College Road. *Tel.* 2931.		
D. C. F. Chaundy, Christ Church, Oxford, and	1962[2]	Physics
London. Flat 3, Radnor Lodge, College		
Road. *Tel.* 3711.		
A. R. Duff, Lincoln, Oxford	1962[2]	**Physics**
School House. *Tel.* 61120.		

	Came	Subject
C. Nicholls, Magdalene, Cambridge	1962[2]	Chemistry
8 The College. *Tel.* 61128.		
J. T. Hart, St. John's, Oxford	1963[2]	Classics
Thirlstane House, Thirlstane Road.		
Tel. 4750.		
N. I. Stewart, St. John's, Oxford	1963[2]	English
9 The College. *Tel.* 61129.		
S. C. Wilkinson, St. Edmund Hall, Oxford	1963[2]	Economics
33 Old Street, Upton-upon-Severn.		Politics
Tel. 83 2860.		Careers
M. J. P. Knott, Clare, Cambridge	1965[2]	Maths.
South Lodge. *Tel.* 4764.		
H. J. C. Ferguson, Christ's, Cambridge	1965[2]	Chemistry
3 Christchurch Road. *Tel.* 2120.		
R. G. H. Goddard, St. Edmund Hall, Oxford	1965[2]	History
Ivydene Hall, Albert Road. *Tel.* 61401.		Politics
P. G. Purcell, Royal College of Music	1966[2]	Music
Wychcote, Upper Colwall. *Tel.* 85 40572.		
T. Southall, Brasenose, Oxford	1966[2]	Maths.
67 Charles Way, *Tel.* 3493.		
R. G. Penman, Pembroke, Cambridge	1967[2]	Classics
Ground Floor, 1 College Grove. *Tel.* 61119.		
F. O. Harriss, King's, Cambridge	1967[2]	Chemistry
54 St. Andrew's Road. *Tel.* 3032.		
J. B. Blackshaw, Lincoln, Oxford	1968[2]	Modern
5 The College. *Tel.* 61125.		Languages
D. M. Penter, King's College, London	1968[2]	Biology
42 Cowleigh Bank. *Tel.* 2900		
A. J. Rambridge, Trinity, Oxford	1969[2]	Classics
Ground Floor, 1 College Grove. *Tel.* 61119		
W. J. Denny, London	1970[2]	Art
10 Teme Avenue. *Tel.* 62001.		
(Lindsay Arts Centre: *Tel.* 64438.)		
P. S. Heath, Farnham College of Art	1970[2]	Art
1 Abergele Cottage, 4 Henley Place,		
Malvern Link.		
A. R. Walwyn, Sussex, and University	1971[2]	Physics
College, Oxford		
Flat 1, Radnor Lodge, College Road. *Tel.* 3711.		
J. P. Knee, St. John's, Cambridge	1972[2]	Maths.
Top Flat, 3 College Grove. *Tel.* 63958.		

2

3

SAPIENS QUI PROSPICIT

———————————

R. de C. Chapman. Headmaster since 1983.

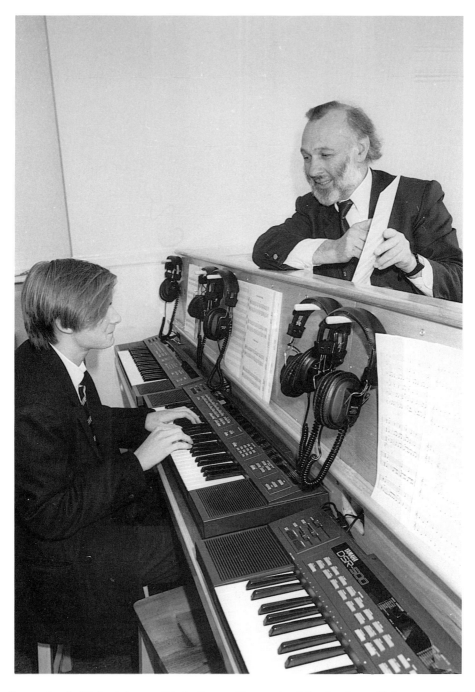

Alan Lumsden initiates his pupil into the excitements of the keyboard laboratory. This was introduced in 1989 and was partly financed by the Malvernian Society.

The language laboratory.

Malvern was one of the first schools to have a language laboratory. This photograph shows the third update of apparatus.

The bed study and Hi Fi
revolution of the eighties.

The ubiquitous computer.

David Peller

1990 David Peller of No. 4, currently in the lower VIth, already runs two electronics companies. There could be no finer evidence of Malvernians moving towards the twenty first century.

Rackets still figures as
an important minor sport.

The Junior Ledder 1990

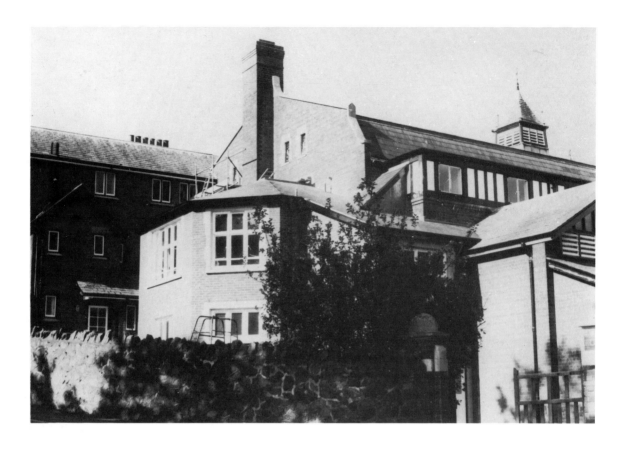

The extension to the old
gymnasium, now known as the
Martin Rogers theatre.

OH WHAT A
LOVELY
WAR

8.00pm
21st -26th Aug
(not thurs)
£3.00(£2.00)
VENUE 44

MALVERN MUSIC
THEATRE

VIEWFORTH CENTRE

1989 The School Play 'Oh What a
Lovely War' was taken to the
Edinburgh Festival in August.

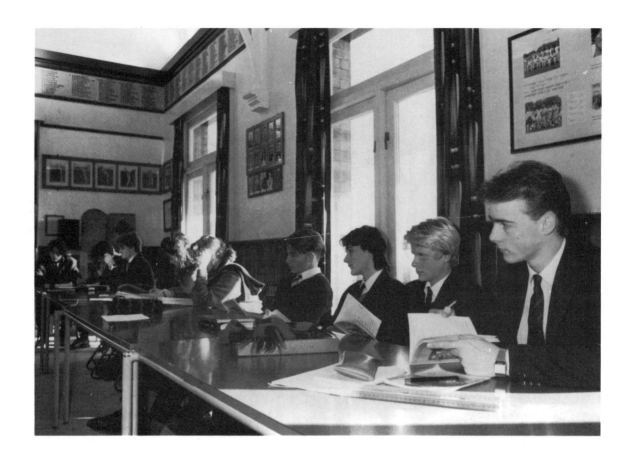

The Long Room as a classroom.

The presence of Ellerslie girls in VIth Form classes
is now a normal feature of school life.

The Long Room Club

The Long Room now serves as a cricket pavilion,
as a class room, and as a Club for those over seventeen.

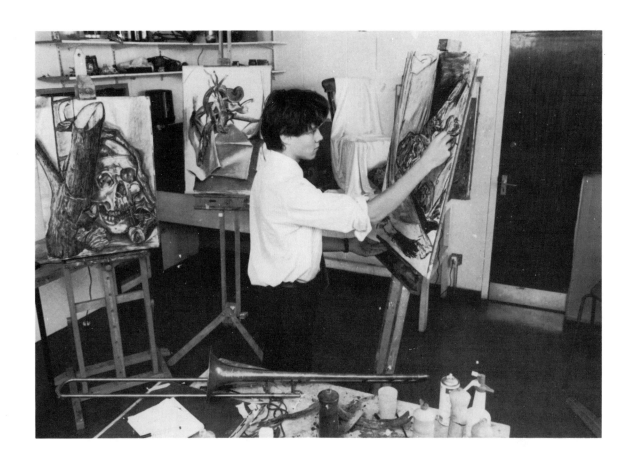

Modern art
The Lindsay Arts Centre, houses
under one roof most art teaching
in the school, including drawing,
painting, sculpture, pottery,
screen printing and photography.

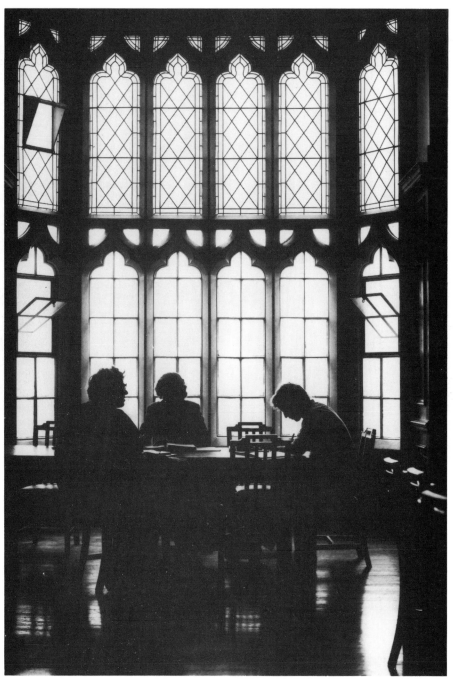

The Classical VIth Form Room
John Hart conducts a classical tutorial, emphasising the need for traditional methods.

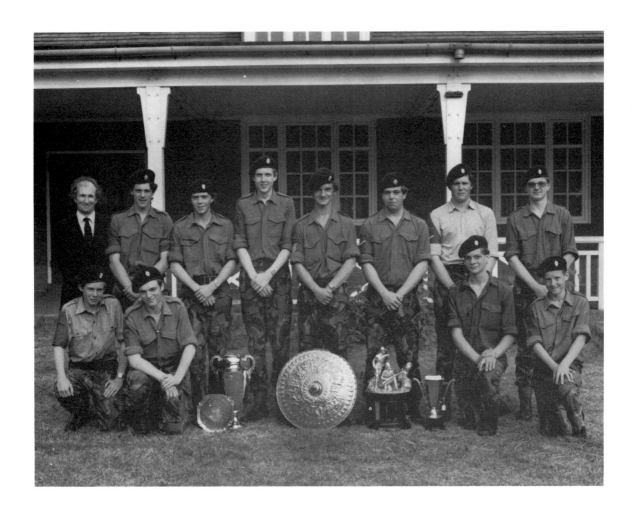

Ashburton Shield 1983

Rear: F.O. Harriss, J. Creed, M.J. Toulmin, A.J. Lidster, A.W. Symonds (Captain), R.E. Bassett, M.W. Kerfoot, T.R. Harrison.
Front: C.S.T.J. Marlow, P.A. Latchford, A. Peers, F.C. Sykes.

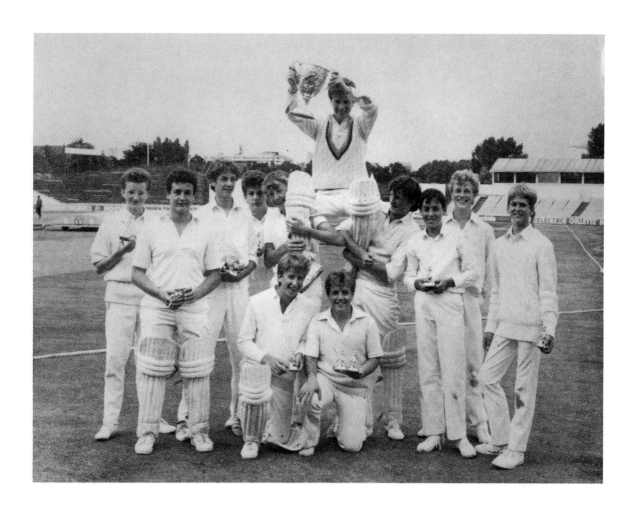

 Lord's Taverners Trophy. 1985

This photograph was taken after victory
in the final at Edgbaston

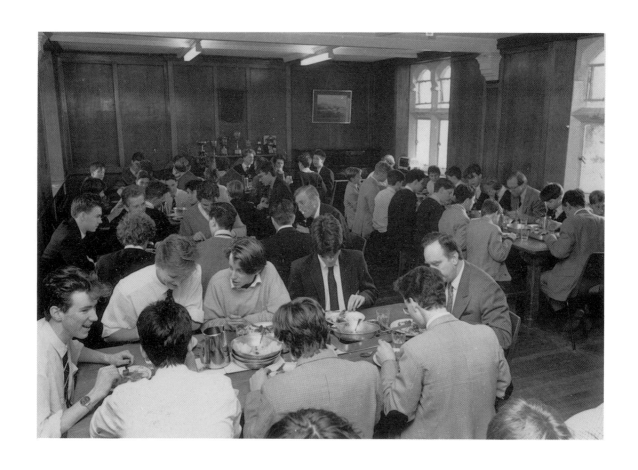

No. 1 Dining Hall

This photograph was taken on January 26th 1990. One hundred and twenty five years ago to the day when the early members of the House awoke to find two feet of snow outside on their first morning at school.

THE HOUSES

School House

1865	Rev. A Faber's private residence
1871	Faber becomes Housemaster in No. 3
	School House renamed College House and houses assistant masters
1876	Rev. A.W.H. Howard begins to turn it into a boarding-house. Leaves later that year through ill health
1877	Faber takes over the House, now again called School House
1881	Rev. C.T. Crutwell
1885	Rev. W. Grundy
1892	Rev. A. St. J. Gray
1897	Rev. S.R. James
1914	F.S. Preston
1937	H.C.A. Gaunt
1942	D.W. Erskine
1956	L.R. Dodd (O.M.)
1960	A.I. Leng
1975	A.R. Duff
1987	A.J. Rambridge

No. 1

1965	Rev. Charles McDowall
1874	Rev. T.H. Belcher
1881	Rev. G.E. Mackie
1887	Rev. H.M. Faber
1913	D.J.P. Berridge
1927	F.W. Roberts
1940	House merged with No. 8
1946	H.C.W. Wilson
1962	N. Rosser
1975	Rev. T.J. Wright
1986	S.M. Hill

No. 2

1865	Rev. F.R. Drew
1881	C. Graham
1883	Rev. M.A. Bayfield
1890	J.N. Swann
1912	W. Greenstock
1927	P.E.A. Morshead
1940	Merged with No. 6
1947	R.H. Bolam (O.M.)
1960	G.V. Surtees
1964	J.M. McNevin
1979	M.J.P. Knott

No. 3

1867	Rev. W.H. Maddock
1871	The Headmaster, Rev. A. Faber. House called School House
1877	Rev. T. Spear. House again called No. 3
1912	P.R. Farrant
1919	R.B. Porch (O.M.)
1933	Rev. W.O. Cosgrove
1951	M.A. Staniforth
1966	A.F. Vyvyan-Robinson
1972	M.G. Harvey
1984	A.C.S. Carter

No. 4

1868	Rev. L. Estridge
1878	Rev. E.L. Bryans
1889	Rev. H.E. Huntington (O.M.)
1893	H.H. House
1924	O. Meade-King
1938	A.H. Chadder
1956	Rev. R.G. Born
1965	R.P. Hooley
1969	G.R. Scott
1981	T. Southall

No. 5

1871	Rev. H. Foster (in what is now No. 6)
1908	L.S. Milward (O.M.). Moves into the present No. 5
1915	F.U. Mugliston
1927	H.M. Robinson
1940	Merges with No. 7
1946	R.T. Colthurst
1949	J. Collinson
1961	G.H. Chesterton (O.M.)
1976	J.B. Blackshaw
1988	C. Hall

No. 6

1891	H.W. Smith, in 'Malvernbury'
1892	C. Toppin. Moves to present No. 5 in 1894, to present No. 6 in 1908
1925	Major H.D.E. Elliott
1938	J.J. Salter
1956	H.J. Farebrother
1968	K.M. Grayson
1980	R.G.H. Goddard

No. 7

1892	R.E. Lyon (O.M.) (Unofficially 1889)
	O. Meade-King locum tenens during the war
1925	Rev. C.E. Storrs (O.M.) – later Bishop of Grafton, N.S.W.
1930	R.T. Colthurst
1948	G.L.M. Smith
1962	D.F. Saunders
1977	H.J.C. Ferguson
1989	A.J. Murtagh

No. 8

1895	C.T. Salisbury, in 'Malvernhurst'; in 'Malvernbury' 1903; in Radnor House 1906
1913	W.W. Lowe (O.M.)
1932	M.C. Nokes
1940	F.W. Roberts
1942	House dissolved
1946	G.W. White
1961	J.L. Lewis (O.M.)
1976	C. Nicholls
1985	R.S.D. Smith

No. 9

1898	E.C. Bullock (O.M.), in 'Cranhill': in 'Malvernbury' 1899; in Roslin House 1903
	G.G. Fraser locum tenens during the war
1917	G.G. Fraser (O.M.)
1927	F.H. Hooper (O.M.)
1942	House dissolved
1946	J.S. Rambridge
1961	R.A. Stobbs
1974	N.I. Stewart
1986	W.J. Denny

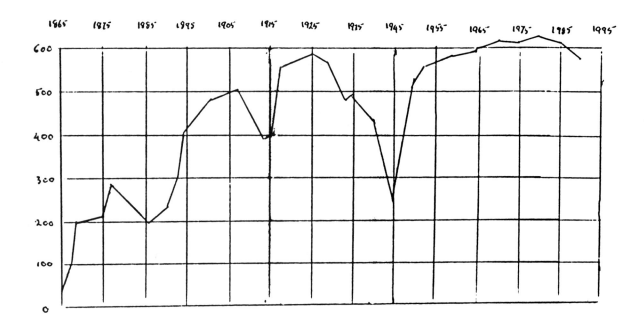

NUMBER OF BOYS IN THE SCHOOL 1865-1990

In 1945 the numbers fell to 263

619 the highest figure is recorded in 1982